IMAGES
of America

PARADISE VALLEY ARCHITECTURE

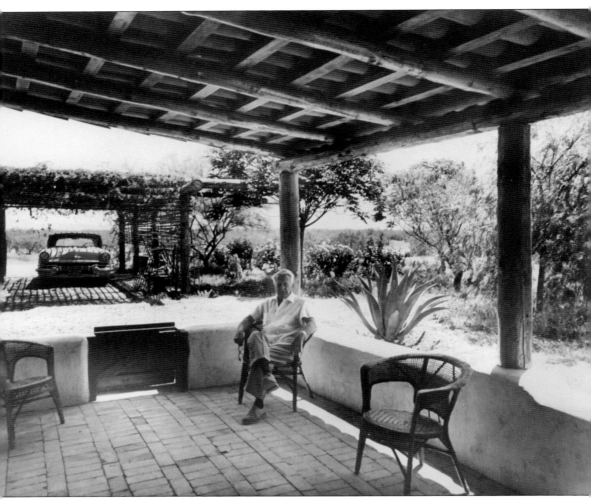

RANCHO LUCERO, 1951. This East Berneil Lane home, Starlight Ranch, was named after favorite quarter horse, "Starlight." Mrs. McKnight, who designed the home, wanted an adobe residence with lush greenery and pleasant gardens. The house was intended to resemble a Mexican village, with a main house, a guesthouse, and a cottage. This photograph of the original owner Robert McKnight looks east toward Scottsdale, capturing the open, undeveloped desert. (Jamey and Linda Cohn.)

ON THE COVER: The original structure was built from 1928 to 1930 and was known as Los Arcos but was later named Casa Hermosa, which means "beautiful house." It was hand built by the local cowboy artist Alonzo "Lon" Megargee III. He studied architecture in Mexico and Spain, which led to this blended Pueblo and Spanish Colonial Revival–style hacienda. In 1947, it became the Hermosa Inn, which served up to 17 guests. The inn closed after a fire in 1987, was renovated, and reopened in 1992. (Scottsdale Historical Society.)

IMAGES
of America

PARADISE VALLEY
ARCHITECTURE

Douglas B. Sydnor

ARCADIA
PUBLISHING

Published by Arcadia Publishing
Charleston, South Carolina

Printed in the United States of America

Library of Congress Control Number: 2012947150

For all general information, please contact Arcadia Publishing:
Telephone 843-853-2070
Fax 843-853-0044
E-mail sales@arcadiapublishing.com
For customer service and orders:
Toll-Free 1-888-313-2665

Visit us on the Internet at www.arcadiapublishing.com

*To my fellow Arizona architects, who have delivered
extraordinary architecture over the decades.*

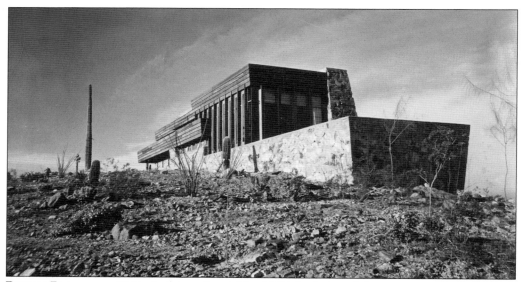

PAUSON RESIDENCE, 1941. Architect Frank Lloyd Wright designed this custom residence for two sisters, artists from San Francisco, California. It was located at 5859 North Thirty-first Street on what is now the Thirty-second Street alignment. This organically composed structure without air conditioning was constructed of desert masonry with natural stones cast into battered concrete walls. A fire in 1943 destroyed the home. (Janie Ellis.)

CONTENTS

Acknowledgments

We extend sincere thanks to various individuals and organizations that have provided many inspiring images and relevant facts for *Paradise Valley Architecture*, including Dana Braccia of the Scottsdale Public Library System, Charles P. Brown, Donald J. Christensen, Jamey and Linda Cohn, Earl and Judy Eisenhower, Janie Ellis, Betsy Fahlman, Melissa Fought, Mike Gildersleeve, Barney J. Gonzales, and Dan Gruber. In addition, support came from Timothy Hursley, Ken and Norma Jones, Don Kaufman, Alison King, Neil Koppes, Jim and Molly Larkin, and Jason Drobish, Natalie Montenegrino, Beth Wickstrom, and Catherine Kauffman of the Town of Paradise Valley Historical Committee. Many thanks are also extended to Melissa Murray; Tina Litteral and Diana Smith, American Institute of Architects; Jerry Meek; Brian Ralphs; Arnold Roy, RA; Tom Silverman; Nicole Snyder; Mary Gayle Stewart; Flora M. Swanson; Dr. Mae Sue Talley; Bill Timmerman; Fred Unger; Gretchen Manker; Heidi Parmenter; Joann Tull; Agnese Udinotti; Pat VanVelser Heard; Flip Weber; and Judy Zuber.

Architects who provided invaluable professional photographs include Kenneth Allen, AIA; W. Brent Armstrong, AIA; William P. Bruder, FAIA; Brian Cassidy, AIA; Jack DeBartolo Jr., FAIA; John Douglas, FAIA; Lawrence Enyart, FAIA; Steven Holl, FAIA; Edward Jones, AIA; Neal Jones, AIA; Hugh Knoell, AIA; Mark Philp, AIA; Matt Sallinger, AIA; Edward B. Sawyer Jr., RA; Vernon Swaback, FAIA; and Mark Vinson, FAIA.

Joan Fudala and JoAnn Handley of the Scottsdale Historical Society provided essential support to this effort, including editing and verifying facts. Deep appreciation goes to Joshua Carter, Nathanial Landreville, and my daughter Elizabeth for helping with production mechanics.

It was a true joy featuring the finest and most inspiring architecture of Paradise Valley as I have lived among it for over 50 years. There has been a rude awakening at the pace at which we are losing such fine work through demolition and insensitive renovations. This book reminds us, once again, how essential it is to create and preserve our archives, record such historically significant images, and expand our resources for future generations, so that they will appreciate our amazing, rich, and diversified architectural history.

INTRODUCTION

Those who know the town of Paradise Valley as one of the most affluent zip codes (85253) in the United States, and home to celebrities and captains of industry, find it difficult to make the mental jump back in time to when the Paradise Valley was an open desert landscape where cattle and sheep grazed during the early 1900s. Let us explore the natural forces, decisive moments, and mindset that created this desirable desert community with open space, magnificent vistas, and a quiet rural lifestyle in the middle of an urban metropolis.

The geology of the area is quite old, and includes a metamorphic type of granite rock called schist. The mountain ranges are relatively young, formed about 14 million years ago as the earth's crust was stretched in the northeast to southwest direction, elevating the mountains and lowering the basins between them. Paradise Valley is in the basin between Camelback Mountain to the south and Mummy Mountain to the north. It is therefore spatially defined by some of nature's most profound architecture—mountains. Camelback Mountain continues to be quite dramatic, with a profile resembling a camel; the west end "camel head" has very sculptural forms, strong shadows, and a coloration that is ever-changing as the sun sets to the west.

Paradise Valley was originally a more remote location northeast of Phoenix, but Phoenix evolved into a large sprawling city, the sixth largest in the United States. East of the community is Scottsdale, a former farming community that now has a population of about 215,000. Scottsdale incorporated in 1951, or 10 years earlier than the Town of Paradise Valley. Phoenix and Scottsdale grew quickly with development and within close reach of Paradise Valley. With the threat of annexations and the risk of them bringing more government, more taxes, and not respecting the open desert environment, the residents debated incorporation starting in 1949; they were eventually successful in 1961. Incorporation enabled this new municipality to control its destiny, while addressing various infrastructure improvements.

Since the 1940s, Paradise Valley has had a consistent commitment to respecting and maintaining the aesthetics of the lower Sonoran Desert and has evolved into a mostly private enclave within the Phoenix metropolitan area for the educated, wealthy, culturally savvy, and well-traveled.

Paradise Valley Architecture focuses on the primary building types found within the community. Within each type, a wide range of architectural characters are featured, from the revival styles as Spanish Colonial, Pueblo, Mission, and Tuscan to more contemporary approaches as Mid-century Ranch, Organic, International, and Post Modern. Along with the specific styles, building forms, structural expression, and materials are also described.

The architecture of Paradise Valley parallels and expresses the town's history, leadership, priorities, and a community-wide vision for a more quiet, relaxed, and desert-rural lifestyle.

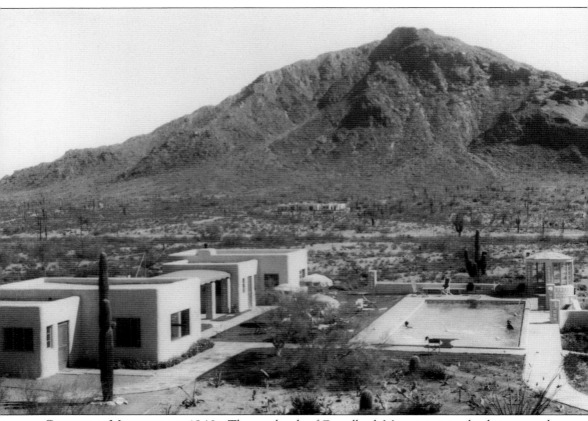

CAMELBACK MOUNTAIN, C. 1940S. The north side of Camelback Mountain is in the distance with Camelback Inn in the foreground. The view captures the open desert wilderness with minimal development throughout Paradise Valley. (Scottsdale Public Library.)

One

EARLY SETTLEMENT: 1890–1930

In the early 1900s, cattle grazed the land that would later belong to the Town of Paradise Valley. Cattle were found east of Mummy Mountain and south to Camelback Mountain. In 1877, the US Congress passed the Desert Land Claim Act, which encouraged economic development of the arid and semiarid public lands of the western states, including the Paradise Valley area. This area was visited in the 1890s by Sam Symonds, Proper D. Parker, and Augustus C. Sheldon, three surveyors with the Rio Verde Canal Company. They were so impressed with the lush desert beauty that it was named "the Paradise Valley." The company invited investors to build a canal system to irrigate the area for farming and ranches, but the canal was never completed, thus development was slow to occur.

In the 1920s, a few custom residences started to arrive, particularly in the eastern foothills of Camelback Mountain. Homes such as the 1924 Donald Kellogg residence and 1929 Estribo were followed by the 1930s Duncan MacDonald, Edward Jones, Mildred Pringle, and Henry Wick residences. Most all of them were of plastered adobe construction and wood-framed roofs, and were of a Mission, Pueblo, or Spanish Colonial Revival style.

In the 1930s, Duncan MacDonald envisioned a different dream than farming, one that was ahead of its time. "Someday this area will be filled with beautiful homes," he told his children. He built a home at the northwest corner of Invergordon Road and McDonald Drive.

Some early homes and schools were converted to guest lodges, including the 1930 Hermosa Lodge, 1934 El Chorro Lodge, and the 1940s Schildman Residence, which became the Desert Lodge. A series of desert guest ranches arrived in the 1940s along East Lincoln Drive and Invergordon Road. Ranch names captured the western ambiance: Diamond Lazy K, Sun 'N Sage, Casa Verde, Desert Lark, and Yellow Boot.

Early settlements in this area epitomized the relaxed rural western environment; during the coming decades, residents strived to retain this character.

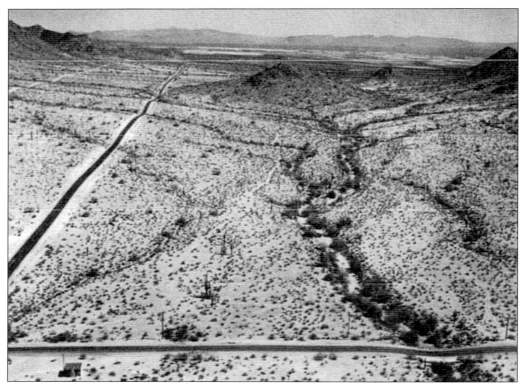

AERIAL, C. 1940S. This view is looking north of Lincoln Drive and along Tatum Boulevard at the future site of the Paradise Valley Country Club and golf course. (Scottsdale Historical Society.)

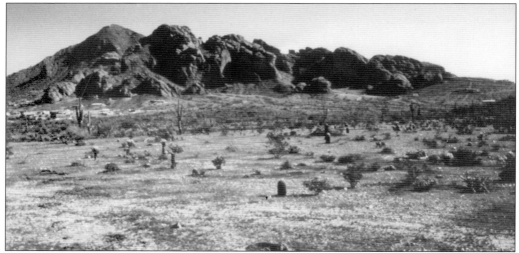

CAMELBACK MOUNTAIN. In 1906, it was named "Camelsback" by the US Geological Survey. During the 1950s and 1960s, pressure was exerted to develop Camelback Mountain, including a proposed restaurant at the top of the camel's hump to be accessed by a cable car system. Community leadership rallied to purchase Camelback Mountain for $500,000, including over 1,300 individual donations, with the balance of about $233,000 allocated by the US government. (Paradise Valley United Methodist Church.)

CAMELBACK MOUNTAIN. The north side of Camelback Mountain defines the southern edge of Paradise Valley. Development and custom residences arrived on the northern slopes. Homes had solid walls facing the more severe southern sun, while windows typically framed the distant valley views to the north. (Scottsdale Public Library.)

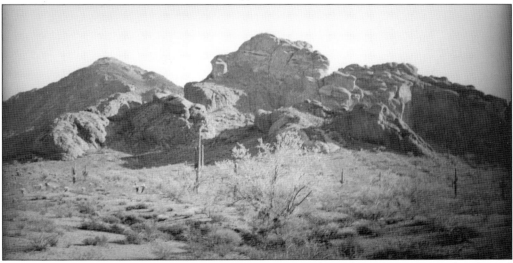

CAMELBACK MOUNTAIN. The north and west sides express the geologic formation and sculptural forms, which make for a dramatic backdrop to Paradise Valley and Phoenix. The head of the mountain is Precambrian granite that is 15 billion years old, with four sedimentary rock layers from the past 25 million years. The mountain reveals the geologic history of the world, not unlike Arizona's own Grand Canyon. (Scottsdale Public Library.)

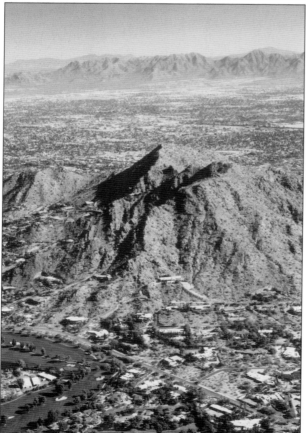

BARRY GOLDWATER ON CAMELBACK MOUNTAIN. Community leadership felt strongly that the upper slopes should be preserved. In November 1964, Preservation of Camelback Mountain Foundation was formed, and Barry Goldwater served as its first chairman. This followed his lengthy service as a US senator (since 1952) and an unsuccessful bid for president in 1964. (Scottsdale Public Library.)

MUMMY MOUNTAIN. This is an aerial view of the south face and western section, which is just above the Paradise Valley Country Club golf course to the left. Note the single-family custom residences in the mountain's lower foothills. A reserve was formed in 1997 to preserve the mountain, and by 1999, four dozen properties were donated, totaling 187 acres for the reserve. Tax benefits contributed to the preservation of this scenic mountain landmark. (Town of Paradise Valley.)

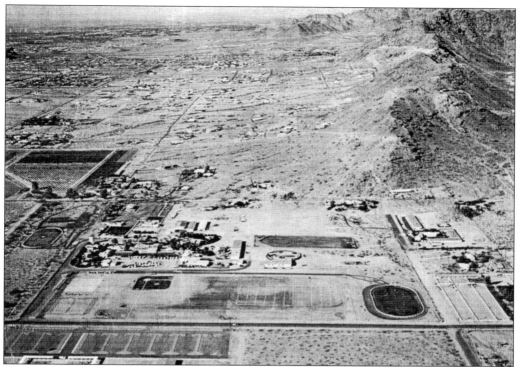

MUMMY MOUNTAIN. Judson School is in the foreground, with Mummy Mountain to the right. Earlier names for the 320-acre mountain were Windy Gulch and Horseshoe Mountain. Charlie Mieg, a longtime resident and landowner, felt such names did not have much marketing appeal. One day, while riding down the future Shea Boulevard alignment, he decided the mountain looked like an Egyptian mummy lying down, which accounts for its name. (Scottsdale Public Library.)

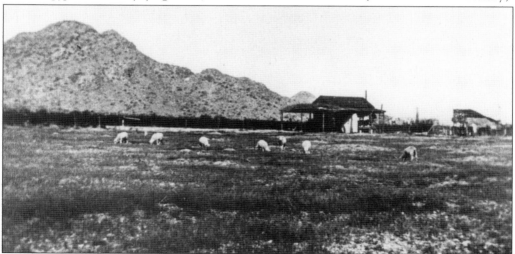

MARJORIE THOMAS RANCH, C. 1909. Marjorie Thomas, a well-known, Boston-trained artist whose paintings featured landscapes and animals, started her own art gallery at the east end of Mummy Mountain on Cheney Drive. Dr. Philip Schneider eventually purchased the area for his family home. (Scottsdale Historical Society.)

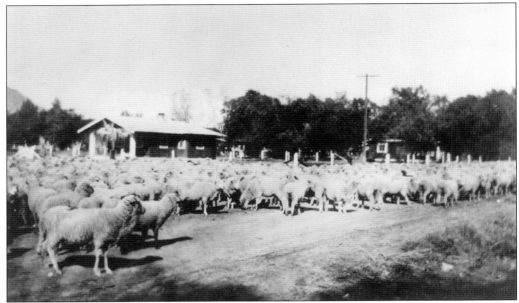

FLOCK OF SHEEP. This image captures the earlier agrarian lifestyle of the Paradise Valley and Scottsdale area. (Scottsdale Public Library.)

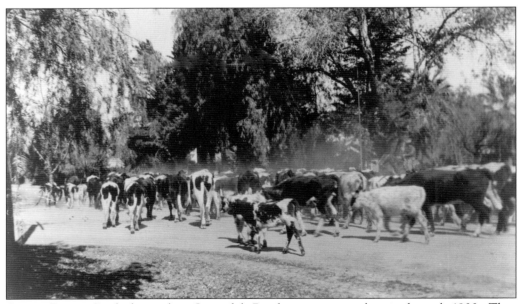

CATTLE DRIVE. Cattle drives along Scottsdale Road were commonplace in the early 1900s. They were driven annually from the north Scottsdale ranches, through downtown Scottsdale, and west to the cattle stockyards on Washington Street. (Scottsdale Public Library.)

McDonald Drive, 1951. This view, looking west along McDonald Drive toward Camelback Mountain, conveys the quiet, rural quality of life at that time. (Scottsdale Historical Society.)

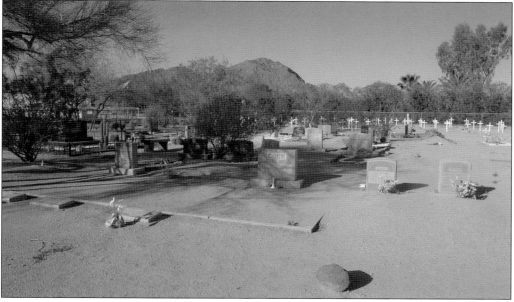

Camelback Cemetery. Hans and Mary Weaver owned a 160-acre homestead where cattle once grazed, and operated a sanatorium in town. Their daughter married Adolph Poenicke in 1915, and within three weeks, the 20-year-old Adolph died and was buried on the family property. In 1916, the Weavers deeded two acres of their property at 8300 East McDonald Drive as a cemetery. (Author's collection.)

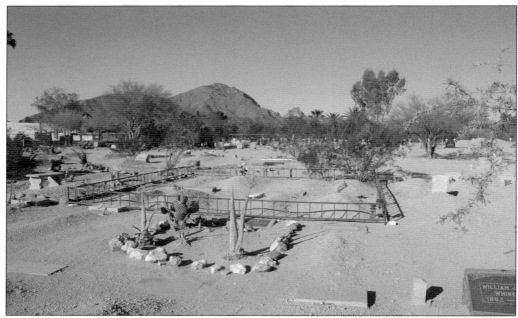

CAMELBACK CEMETERY. The cemetery became the final resting place for about 600 people, including many who died in the 1918 flu epidemic, Mexican-Catholics, military veterans, and members of prominent families such as Herberger, Kiser, and Powell. (Author's collection.)

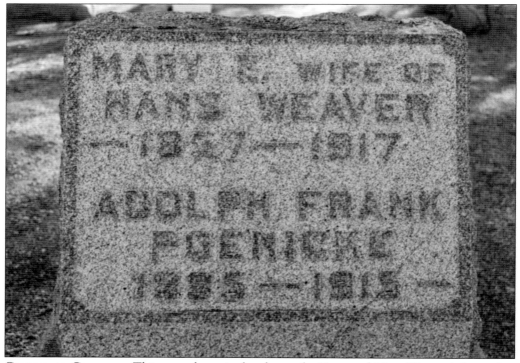

CAMELBACK CEMETERY. This carved granite headstone for Hans and Mary Weaver is located at their cemetery plot. (Author's collection.)

Two

TOWN OF PARADISE VALLEY INCORPORATON AND FACILITIES: 1949–2011

After World War II, development became more active in what was then an unincorporated community in Maricopa County. Until that time, it was a rural area with a few scattered residences and an occasional commercial enterprise. The homes were smaller, but located on one to five acres. Phoenix and Scottsdale were considering annexations, including this valley, during the 1950s. Residents felt their rural lifestyle was under threat, fearing amplified commercial activity, denser zoning, and increased taxes. The Citizens Committee for the Incorporation of The Town of Paradise Valley, Arizona, circulated petitions to support incorporation beginning in 1949. This initiative was hotly debated. In April 1961, petitions were submitted to the Maricopa County Board of Supervisors and on May 24, 1961, incorporation was approved. At incorporation, the town was about 2.69 square miles and had a population of 1,200. The new 1964 Land Use Plan reflected restrictive zoning to limit commercial enterprise and blend it with the residential character. By 1969, the population was 6,460; Paradise Valley was the fasting growing city in the county.

In the 1980s, property annexations allowed the town to grow to 14 square miles and 11,000 residents. At this time, town leaders drafted the First General Plan, which reinforced their rural desert lifestyle. In 1972, the Hillside Protection Ordinance was enacted to discourage development on upper elevations while managing them on lower elevations, and in 1980, the Mummy Mountain Reserve was established to further preserve town land from development. In 1997, the Mummy Mountain Reserve Trust was created to maintain the natural landscape, wildlife, and aesthetics of the town hillsides.

By 2001, the town increased to 16.5 square miles with a population of 13,315. By this time, there were three water companies, four trash companies, and a fire service partnership with the City of Phoenix. The population appears to have peaked in 2000 at 13,664; by May 24, 2011, at the 50th anniversary, it dropped slightly to 12,280. At that time, there still remained two unincorporated Maricopa County islands within the town limits—the Franciscan Renewal Center and the Clearwater Hills Subdivision.

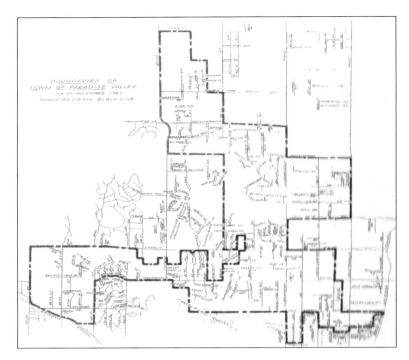

INCORPORATION MAP, C. 1961. This map reflects the new boundaries of the Town of Paradise Valley. Henry Wick, the owner of Judson School, agreed to allow the 55-acre Mockingbird Lane property within the new town, which helped deliver the minimum land area required for incorporation. About this same time, citizens voted to name a few streets after birds, including Hummingbird Lane, Blue Bird Lane, Cactus Wren, and Mockingbird Lane. (Town of Paradise Valley.)

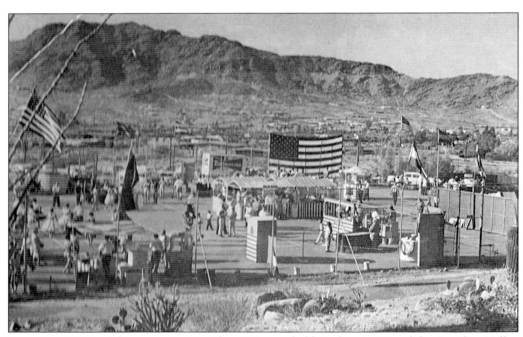

PICNIC, C. 1960s. This community-wide picnic was held in the vicinity of the Paradise Valley Racquet Club. (Town of Paradise Valley.)

TOWN MARSHALS. This group photograph shows the early town marshals, who provided public safety. With fewer marshals in this smaller community, they invested in state-of-the-art communications and traffic controls as synchronization systems. In 1995, photographic radar was installed, a first in the United States. With follow-up data, it proved to lower the number of traffic accidents. (Town of Paradise Valley.)

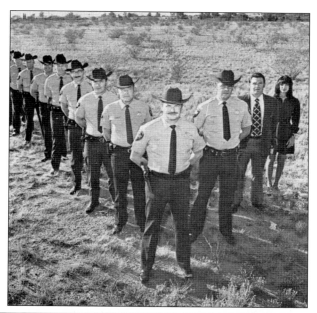

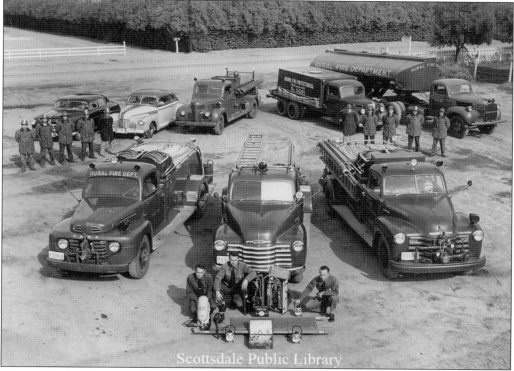

RURAL METRO DEPARTMENT. During the earlier decades, Rural Metro Department, a private company, provided fire service to the Town of Paradise Valley and county islands. In 1972, the town funded 13 new fire hydrants; along with others provided by developers, a more favorable fire insurance rating was received. In the late 1990s, the town developed a new fire service relationship with the City of Phoenix. (Scottsdale Public Library.)

ECHO CANYON PARK. Echo Canyon Park is at the northwest side of Camelback Mountain and was defined by dramatic rock outcroppings. It has been used for picnics and as a staging area for hikers and rock climbers over the decades, as well as this c. 1910–1920 Ingleside Inn Resort Pow Wow. The park was officially formed by the Town of Paradise Valley in 1973. (Scottsdale Public Library.)

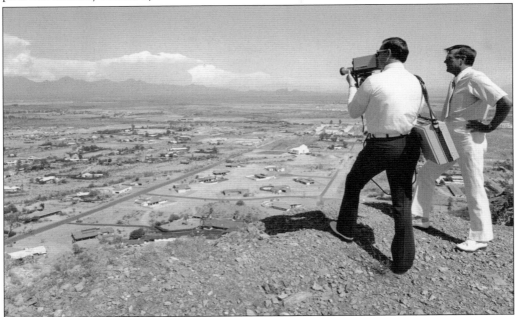

MOUNTAINTOP VIEW, 1974. Town marshal Ronald W. Dalrymple and town manager Oscar A. Butt overlook the Town of Paradise Valley from Mummy Mountain. They were demonstrating how a camera could zoom in on potential intruders, thereby discouraging burglaries. (Town of Paradise Valley.)

Paradise Valley Town Hall, 1973. The first town council met in a guesthouse on Quail Run Road and then rented a building on Malcomb Drive. The town acquired the 6401 East Lincoln Drive property for a municipal campus, and on April 8, 1973, broke ground for the new town hall with Mayor Bob Tribken, other elected officials, dignitaries, and citizens at the ceremony. (Town of Paradise Valley.)

Paradise Valley Town Hall, 1974. Michael and Kemper Goodwin Architects of Tempe, Arizona, were hired to design the new town hall. Staff architect William P. Bruder worked on the design and later founded his own successful architectural practice. It was a 6,672-square-foot, tent-like structure with a clay tile roof, exposed rough-sawn lumber, and plastered walls. Reaction to the design included "striking, but with subtle accents." The project was paid for by accumulated town funds. (Town of Paradise Valley.)

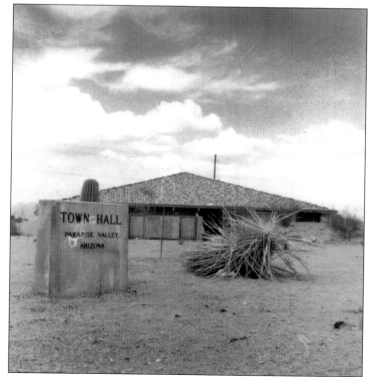

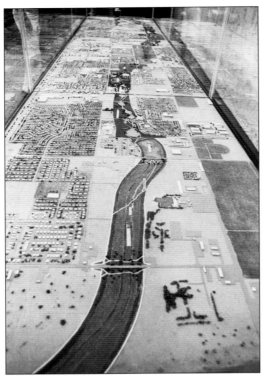

INDIAN BEND WASH. Northeastern Paradise Valley experienced periodic flooding. In 1949, the Berneil Ditch and Drainage Channel were constructed; later, in 1974, the ditch and channel were deepened and widened. In 1973, the town adopted the Flood Plain Regulations, which required the Indian Bend Wash be developed as a green belt, not unlike Scottsdale's flood control project. This model shows some of the Indian Bend Wash infrastructure improvements. (Scottsdale Public Library.)

TOWN OF PARADISE VALLEY MASTER PLAN, 1992. To guide the future of the 12-acre municipal campus, a master plan was created. It showed the future police station, public services, town hall expansions, parking, vehicular and pedestrian circulation, and landscape. The architect was Jones Studio Inc. (Jones Studio Inc.)

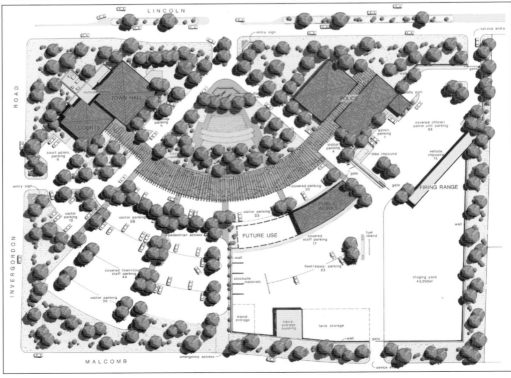

HILLSIDE PROTECTION. The desire to protect the hillsides was formalized in the 1972 Hillside Building Regulations and 2003 Hillside Guidelines. Such regulations attempted to manage building volumes, wall heights, and coloration. Protection continued in the early 1980s with 100 acres of Mummy Mountain properties donated. In addition, repairs were made to the existing hillside scars with a new applied treatment. (Scottsdale Historical Society.)

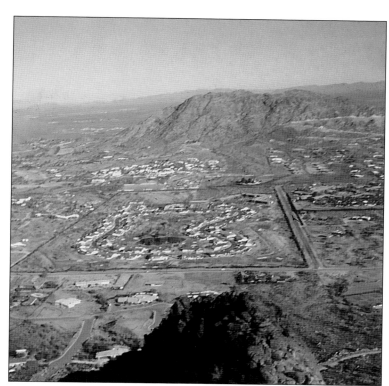

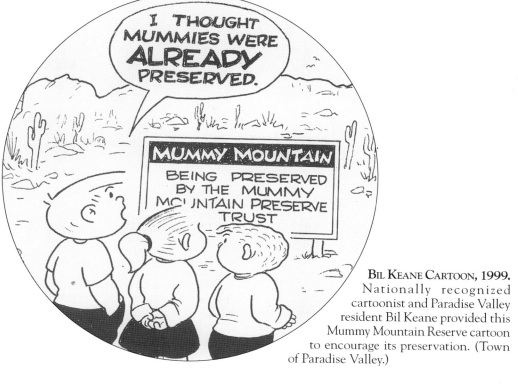

BIL KEANE CARTOON, 1999. Nationally recognized cartoonist and Paradise Valley resident Bil Keane provided this Mummy Mountain Reserve cartoon to encourage its preservation. (Town of Paradise Valley.)

DOUBLETREE RANCH ROAD MEDIAN. 1972 brought a curvilinear roadway and landscaped median from Fifty-eighth to Sixty-second Streets, which slowed down vehicular traffic. In 1974, the first bicycle path from Scottsdale Road to Tatum Boulevard on this same street was constructed. Artist Lew Davis called his home, which was located on the current Cosanti property, Double Tree Ranch. This influenced the street name. (Author's collection.)

LINCOLN DRIVE MEDIAN. The town completed the widening of Lincoln Drive from two to four lanes, with an integrated desert landscaped median, in 1977. Infrastructure improvement aesthetically transformed this main arterial street from Tatum Boulevard to Scottsdale Road. Lincoln Drive is named after John C. Lincoln, an industrialist from Cleveland, Ohio, who moved his family to the Phoenix area in the early 1930s. (Author's collection.)

TATUM BOULEVARD CONSTRUCTION. Tatum Boulevard construction is pictured south of Lincoln Drive looking toward Camelback Mountain during a street widening and median-improvement project. (Town of Paradise Valley.)

TATUM BOULEVARD CURVE. Tatum Boulevard (at about Mockingbird Lane) had a tightly curved section on a hillside that likely caused some serious accidents. The town reconstructed the street in 1990 with a more gradual curve and better sight lines. Tatum Boulevard is named after Russ F. Tatum, a real estate developer active in this area around the 1930s who unfortunately lost his properties during the Great Depression. (Author's collection.)

MOUNTAIN VIEW ESTATES. This 1977 development was a major departure from the typical residential R-43 zoning with a 40-acre, single-family residential development that originally proposed 88 lots, but was legally reduced to 56. Exterior character reflected a horizontal profile, with some low-pitched roofs and shaded walls. John Rattenbury of the Frank Lloyd Wright Foundation was the architect; this project was one of their earliest ventures into mass-produced housing. (Authors' collection.)

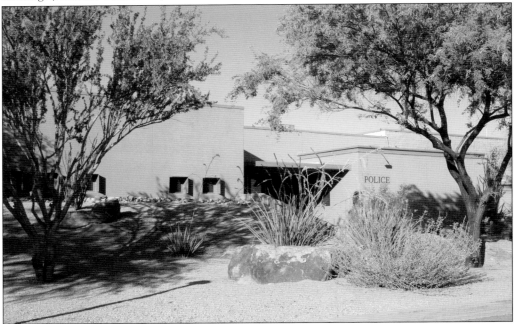

POLICE COURT. In 1995, the town broke ground on a new Police Court building. The plastered masonry walls, steel shading devices, and entry canopies were compatible with the original Town Hall structure. The architect was DLR Group. (Author's collection.)

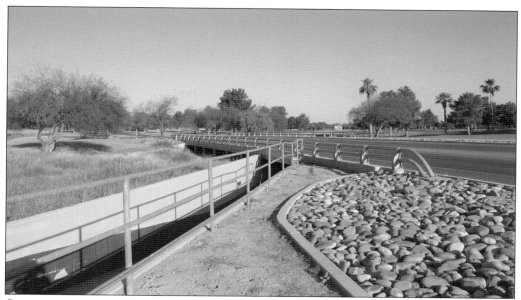

CHANNELIZATION OF INDIAN BEND WASH. In December 1972, there were new federal flood plain regulations, which encouraged development of the Indian Bend Wash as a greenbelt. With such infrastructure improvements, residents became eligible for federal flood insurance, and channelization along its raised banks put properties outside a flood zone where they could become residential subdivisions. In 1983, a bridge was constructed at Doubletree Ranch Road to alleviate flooding. (Author's collection.)

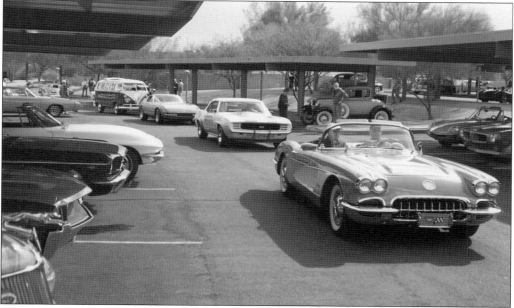

VETERANS' APPRECIATION VINTAGE CAR SHOW, 2009. The Town of Paradise Valley mayor and council have been sponsoring the Veterans' Appreciation Vintage Car Show since 2004. It is an opportunity for residents to display and discuss their classic automobiles. The event also honors veterans and active-duty military. (Town of Paradise Valley.)

BARRY GOLDWATER MEMORIAL. The Barry Goldwater Memorial was constructed on 1.25 acres in 2004 at the northeast corner of Tatum Boulevard and Lincoln Drive. The memorial functions as a quiet park retreat with desert landscaping, low stone walls, seating, and interpretative markers. The landscape architect was Michael Dollin of Urban Earth Design LLC, who describes it as a "scenic public place." (Author's collection.)

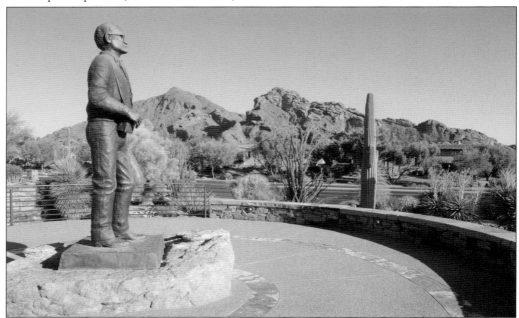

BARRY GOLDWATER MEMORIAL. The focal piece within the memorial is a cast bronze Barry Goldwater sculpture by Joe Beeler, a member of the Cowboy Artists of America. The sculpture is facing southwest (where Goldwater's original residence was located) and the dramatic western sunsets, which Senator Goldwater enjoyed. (Author's collection.)

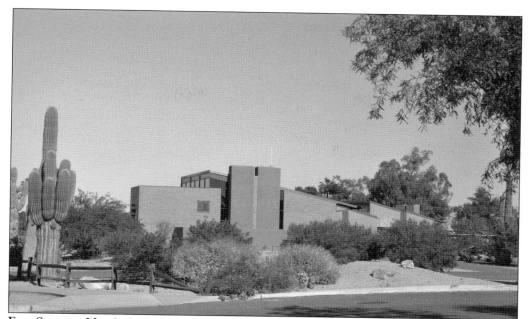

FIRE STATION NO. 2, 2009. Fire Station No. 2 is located at 6539 East Lincoln Drive, just east of the existing municipal campus. This 9,500-square-foot structure provides invaluable fire protection and life saving services. It is one story, with varied sculptural volumes, cantilevered shade canopies, and natural materials such as exposed masonry, metal roofing, and tinted glazing. Desert landscaping provides a pleasant and appropriate setting. The architect was LEA Architects LLC. (LEA Architects LLC.)

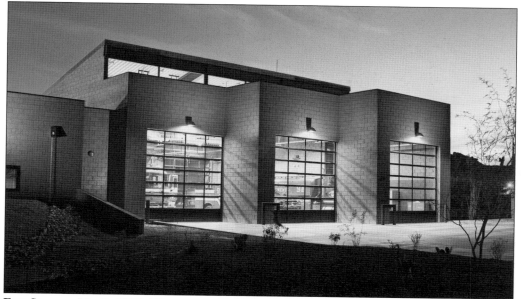

FIRE STATION NO. 2, 2009. This exterior view shows the three vehicular bays with a stepped floor plan to mitigate the building's volume. In addition, glazed roll-up doors display the firefighting equipment to the street and public, and a continuous clerestory above admits daylight into the equipment area. (LEA Architects LLC.)

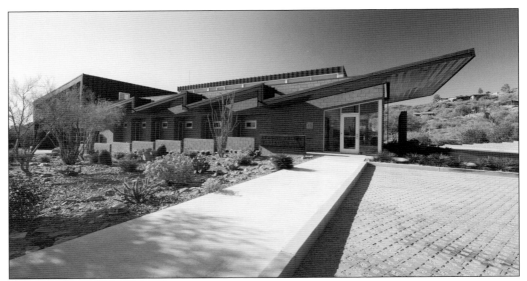

FIRE STATION NO. 1, 2010. The replacement facility for the original 1974 Rural Metro Fire Station was constructed at 8444 North Tatum Boulevard. The 8,000-square-foot facility was constructed of exposed masonry walls, rusting steel pitched roofs, shade canopies, and tinted glazing. The angled roof profile is a metaphorical reference to the surrounding Phoenix Mountains. The architect was LEA Architects LLC. (LEA Architects LLC.)

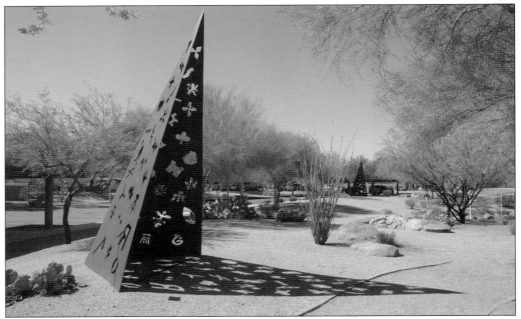

UNIVERSAL SOLAR SHADOWGRAPH. Jeff Zischke's 1992 sculpture has rusted plate steel components 15 feet high by 7.5 feet wide. The piece was commissioned by the Arizona Commission on the Arts, fabricated in Detroit, and first exhibited in Tempe. It was then on loan to the Town of Carefree followed by the Town of Paradise Valley, which purchased it in 2007. The town has a long heritage of supporting its community artists, specifically with the Town Art Jury, initiated in 1974. (Author's collection.)

Three

ACADEMIC PURSUITS: 1928–2008

The roots of academic opportunity for Paradise Valley residents started in 1928 with the private college preparatory academy named Judson School. Since that time, a number of other private schools and two public schools have opened; most of them continue to function today.

Judson School provided kindergarten through 12th grade on a 55-acre property at the east end of Mummy Mountain. The school graduated a host of well-known citizens over the years. Unfortunately, it closed in 1999 when the property was sold to Cachet Homes. Existing structures were demolished in 2000. The property was then redeveloped into a custom residential subdivision.

During the 1950s, the Desert Art Gallery and School was offering classes by professional fine artist Lew E. Davis and his wife, sculptress Mathide Schaefer Davis. The school site was at the southeast corner of Invergordon Road and Lincoln Drive. This site eventually became the Town of Paradise Valley municipal campus in the early 1970s.

Scottsdale Unified School District constructed the first public school in Paradise Valley, the 1957 Kiva Elementary School. In 1974, the district constructed a second school, Cherokee Elementary School.

In 1960, Mae Sue and Franz Talley started the Talley Academy on Stanford Drive but soon encountered zoning and financial challenges. Such difficulties were overcome, and the school was renamed Phoenix Country Day School in 1961.

Paradise Valley Day School opened about 1960 at 6602 East Malcolm Drive. Kachina Country Day School then purchased the property in July 1983 and offered kindergarten through fourth grade classes.

Camelback Desert School operated at 6050 North Invergordon Road from 1952 to 2009 and is now the private Montessori Academy that provides preschool and a charter kindergarten through middle school programs.

Tesseract School, a private school that is among other facilities in the Phoenix metropolitan area, was constructed at Tatum Boulevard and Doubletree Ranch Road in 1988. It serves kindergarten through fourth grade.

By the 2000s, there were 13 public and private schools in the town of Paradise Valley. Educational resources were also extended to numerous reputable preschools, managed by various religious organizations.

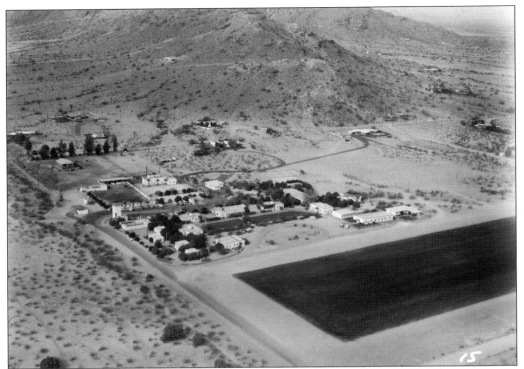

JUDSON SCHOOL, 1928. This aerial view shows the original Judson School campus within the open desert and the cluster of one-story plastered adobe structures. They once stood on 55 acres of a remote desert site at North Mockingbird Lane, named after founder George A. Judson. (Scottsdale Historical Society.)

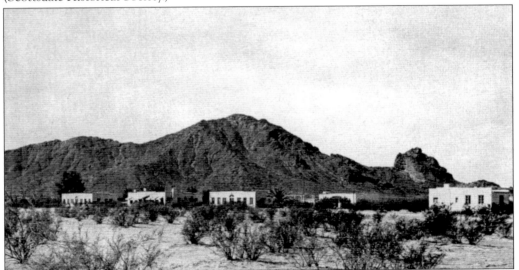

JUDSON SCHOOL, 1928. The academy served coed boarding and day students for kindergarten through 12th grade. The Wick family, and more recently Kent Wick, vice president, managed the school from 1945 until it closed in June 2000. The school was the oldest independent college preparatory school in Arizona. (Scottsdale Historical Society.)

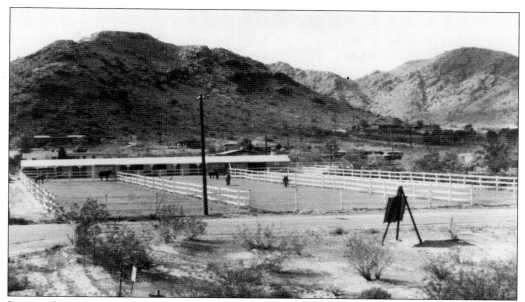

JUDSON SCHOOL. Corrals and buildings are pictured at Judson School, which was located at the east end of Mummy Mountain. After the school closed in 2000, the land was developed as a residential community with high-end custom homes. (Scottsdale Public Library.)

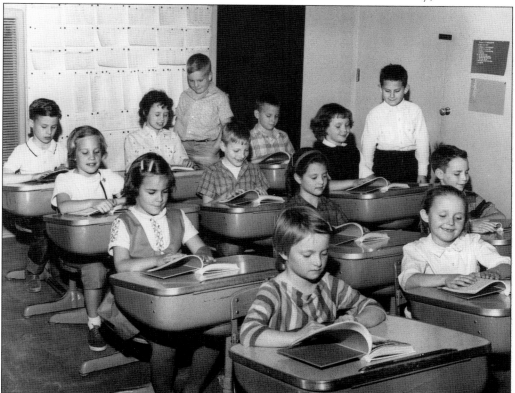

JUDSON SCHOOL, C. 1963–1964. This is a typical fourth grade classroom. (Beth Wickstrom.)

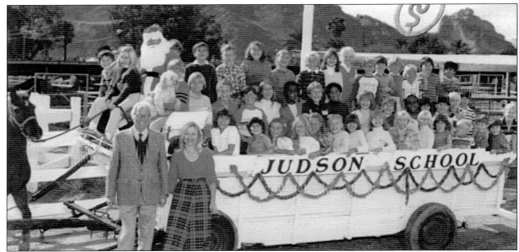

Judson School Wagon. Judson School often took field trips with its young students. In the early days, they could go across Paradise Valley and not see anyone because of the lack of development. (Town of Paradise Valley.)

Desert Art Gallery and School, 1956. During the 1950s at the southeast corner of Invergordon Road and Lincoln Drive, painter Lew E. Davis and his wife, sculptress Mathilde Schaefer Davis, taught beginning and advanced adult art classes. Susan Ferguson also taught children's art classes. The school hosted many multicultural events, including this open air Sunday school class for the newly formed Valley Presbyterian Church. The structure was eventually removed to allow for the construction of a new Paradise Valley Town Hall. (Flora M. Swanson, Valley Presbyterian Church.)

CAMELBACK DESERT SCHOOL. This private preschool was started in 1950 by Marian Moore and Paula Nelson in Phoenix, and then in 1952 at 6050 North Invergordon Road. William Barton purchased the school in 1970 and expanded programs to include grades one through eight. The four-acre campus has evolved over the years with additional one-story structures, playgrounds, and various ball fields. Since 2009, the property has been owned by the Montessori Academy. (Author's collection.)

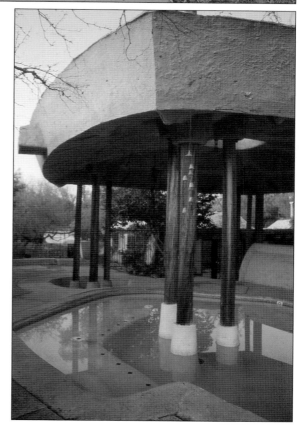

EARTH HOUSE, 1992. Paolo Soleri arrived at Taliesin West in 1953 and purchased five acres at 6433 East Doubletree Ranch Road in 1956. From 1956 to 1957, construction was underway on his Earth House, which experimented with casting concrete shells over sculpted earth. Later techniques included structures elevated with vertical columns and cooler microclimates based on an understanding of solar angles and natural winds. (Author's collection.)

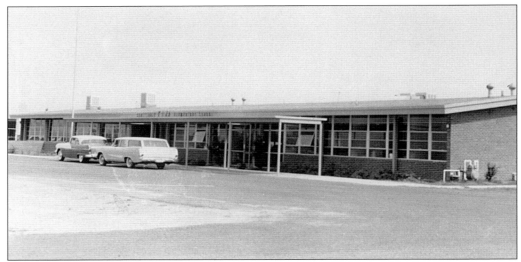

KIVA ELEMENTARY SCHOOL, 1957. Located at 6911 East McDonald Drive, Kiva Elementary School was the first public school built in Paradise Valley and operated by the Scottsdale Unified School District. It originally served kindergarten through eighth grade. Building components are prototypical in nature, arranged with long east-west classroom wings for better solar orientation, and connected by shaded breezeways. Glazing faces north for soft, diffused daylight in each classroom. The architect was David G. Haumerson. (Scottsdale Historical Society.)

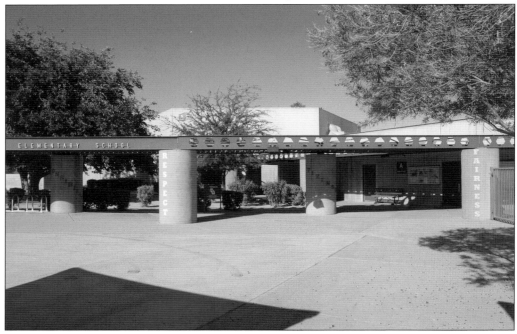

CHEROKEE ELEMENTARY SCHOOL. Cherokee Elementary School is a public Scottsdale Unified School District Pre-kindergarten through fifth grade program located at 8801 North Fifty-sixth Street. Originally, it served kindergarten though eighth grade in the 1974 structures. Structures are exposed concrete wall panels with shaded arcades and a fascia of castellated steel beams. The architect was Michael and Kemper Goodwin. (Author's collection.)

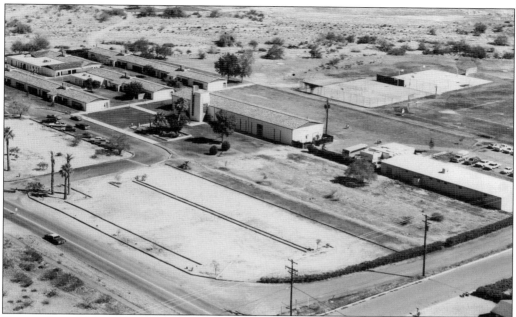

TALLEY ACADEMY, 1972. Mae Sue and Franz Talley started a private school in 1960 at 3901 East Stanford Drive. Persevering over zoning restrictions and debts, the school survived to become the Phoenix Country Day School in 1961 and grew to a kindergarten though eighth grade school. Original structures were plastered, painted white with red clay tile roofs, and had steel-framed windows. The architect for the 1964 round Science Building was Gonzales and Ludlow. (Phoenix Country Day School.)

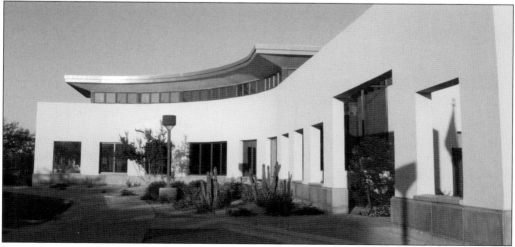

PHOENIX COUNTRY DAY SCHOOL, 1994. Knoell & Quidort Architects has completed a series of additions to the 108,000-square-foot campus that grew to 40 acres. In the mid-1990s through 2008, most classrooms were replaced or renovated. Gunnar Birkerts, FAIA, of the Regional AIA Award Jury, praised the "simple arrangement of stuccoed walls, colonnade and courtyard, and how, through minimal means, it created new public space for the school. This is a good example of regional architecture; it has a sense of dignity and sets a good precedent for the campus." (Knoell & Quidort Architects.)

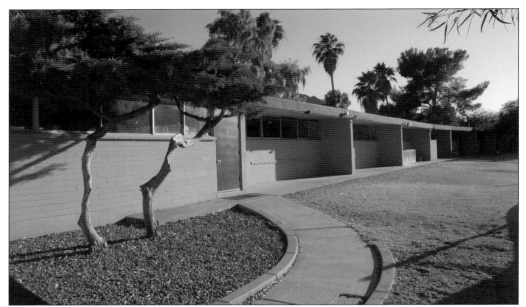

PARADISE VALLEY DAY SCHOOL. This private preschool through eighth grade school, located at 6602 East Malcomb Drive, was built on four acres around 1960 by Carl and Kacki Vinsel. The school eventually closed. Kachina Country Day School purchased the property in 1983, and the land expanded to seven acres. This school would grow from 180 students to 300, but the owners attempted to sell it in 2012. The classroom had good orientation, with north-facing windows that allowed daylight to enter. (Author's collection.)

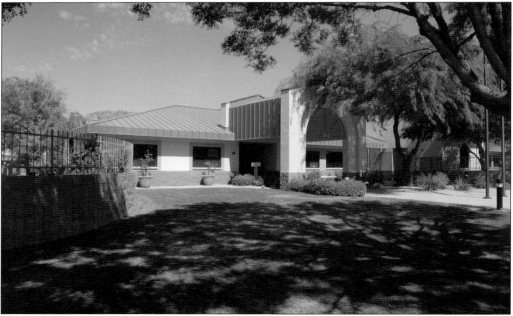

TESSERACT SCHOOL. This nonprofit school was founded in 1988, and since 2001 had its lower school campus at 4800 East Doubletree Ranch Road for pre-kindergarten through fourth grade. It is a Post Modern design with a symmetrical front facade. (Author's collection.)

Four

DESERT RANCHES, RESORTS, CLUBS, AND RECREATION: 1928–2000

Although the 1930s Great Depression hit local farmers and businesses severely, new guest ranches and resorts were attracting wealthy easterners to the Paradise Valley and Scottsdale area.

In 1936, Camelback Inn was jointly developed by Jack Stewart and John C. Lincoln on the southern slopes of Mummy Mountain. The Pueblo Revival architecture conveyed an inviting and relaxed desert environment for its guests.

El Chorro Lodge was a 1937 adaptation from the Judson School for Girls into a guest lodge and restaurant. This same year, the Squaw Peak Inn was built. In 1943, it became a guest ranch.

After World War II, there was a new need for guest ranches, resorts, and tourist accommodations. Americans and foreigners had a desire for travel throughout the United States given the affordable and efficient trains, aircraft, vehicles, and improved highway system. Television and movie Westerns also added to the allure of this special place in the desert.

Paradise Valley started attracting visitors in the 1940s and 1950s to a series of desert guest ranches along Lincoln Drive and Invergordon Road. They included the Sun 'N Sage, Desert Lark Ranch, Flying T Ranch, and Desert Lodge. As more luxurious resorts were developed on many of these same properties, the original ranches were removed by the 1960s.

The 1950s were active with new clubs and resorts being built, such as the 1953 private Paradise Valley Country Club with an 18-hole golf course and large swimming pool. Paradise Valley Racquet Club on Camelback Mountain was built in 1957 and evolved into the 1969 John Gardiner's Tennis Ranch, and ultimately into The Sanctuary in 2001. Jim Paul developed Mountains Shadows Resort in 1958, which proved a popular destination for the next 45 years.

In 1956, *Life Magazine* featured Paradise Valley and Scottsdale as a place for the rich and famous, contributing to its appeal and attracting more visitors and residents.

The 1960s brought the new Shangrila Resort, and in the 1970s, the 1971 Camelback Golf Club, 1975 Scottsdale Sheraton Resort, and the 1978 La Posada Resort. During this time, the town adopted the 1974 Regulations Governing Resorts and Hotels. Later, the 1980 Los Alamos Resort and 1984 Loew's Paradise Valley Resort were developed along Scottsdale Road.

By the 2000s, there were 12 resorts in the Town of Paradise Valley.

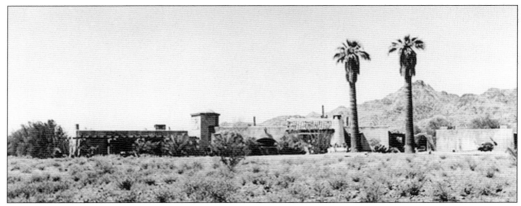

CASA HERMOSA, 1941. The original 1928–1930 Los Arcos sat on six acres at 5532 North Palo Christi Road and was later named Casa Hermosa. Local cowboy artist Alonzo "Lon" Megargee III built the home by hand. He was responsible for the design and construction of over half a dozen residences in Paradise Valley, Phoenix, and Sedona. This historic Spanish Colonial and Pueblo Revival styled hacienda with a one room studio became the Hermosa Inn in 1947. A fire in 1987 required its closure for several years. (Hermosa Inn.)

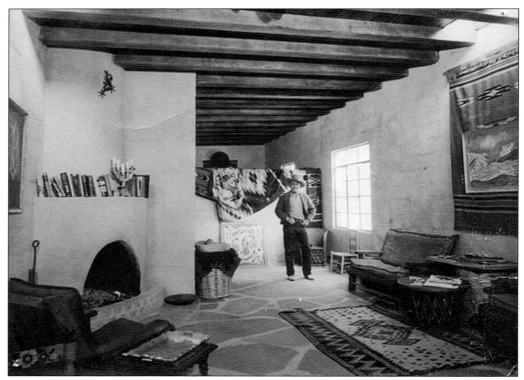

CASA HERMOSA. The interior of the original Casa Hermosa with Alonso "Lon" Megargee III is shown here. Walls were constructed of 42-inch-thick adobe with posts and beams of old railroad beds and bridges. Jennifer and Fred Unger bought the 6.5-acre property in 1992 and expanded the existing 17 guest rooms to 35 in 2003. Some rooms have beehive fireplaces and private patios. The original property offered a swimming pool, golf course, and horseback riding. (Hermosa Inn.)

ALONSO MEGARGEE III. Born in 1883, Megargee came to Arizona from Philadelphia at 13 to be a cowpuncher. He toured with a wild west show, ranched in Cave Creek, and was also a poker dealer, artist, and builder. Governor Hunt commissioned Megargee to paint murals at the Arizona Capitol for $7,000. He became a prolific cowboy artist with paintings, wood-block prints, pulp magazine covers, beer advertising, and the Stetson company logo to his credit. He moved to Sedona in 1947, where he died in 1960. (Hermosa Inn.)

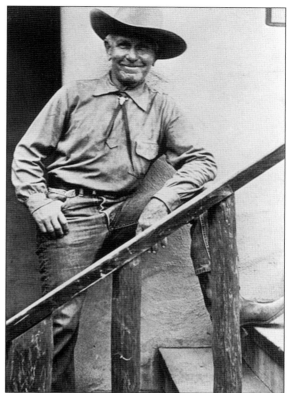

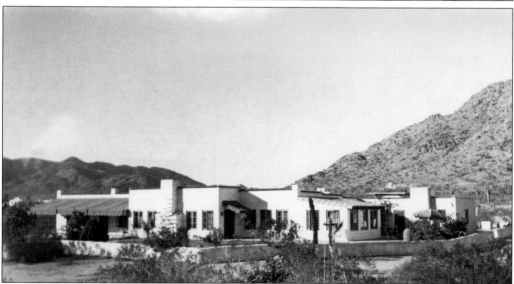

EL CHORRO LODGE, 1934. The original structure sat on 11 acres at 5550 East Lincoln Drive and was home to the Bell family, later becoming the Judson School for Girls (built by John C. Lincoln), which closed after only two years. The Bells then sold to the Judsons, who in turn sold to Mark and Jan Gruber. The Grubers adapted the property into a guest ranch and restaurant in 1937, managing the lodge for 50 years. (Scottsdale Historical Society.)

EL CHORRO LODGE, 1934. Seen here is the original interior with exposed adobe brick walls, wood lintels, and local artisan features. (Town of Paradise Valley.)

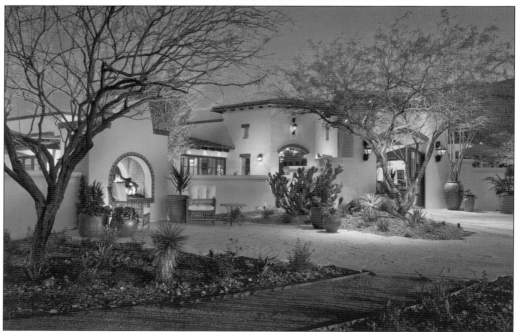

EL CHORRO LODGE, 2010. The 27,397-square-foot lodge was sold by Mark and Jan Gruber to Joe Miller and eventually to Jacque Dorrance. In 2010, it reopened after architect Candelaria Design Associates LLC designed a major remodel and expansion project. New fireplaces, solar panels, and bocce courts were provided, while saving two original *casitas* that still stand on the front lawn. *El Chorro* comes from Peruvian Spanish and means "running stream." (Mark Boisclair Photography, Desert Star Construction.)

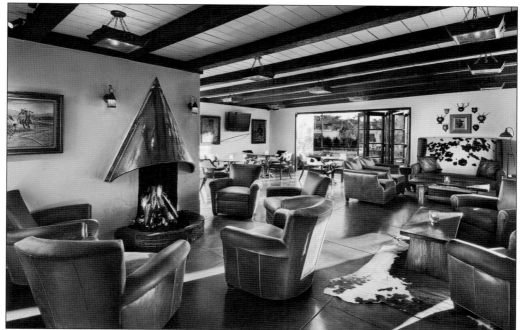

EL CHORRO LODGE, 2010. The remodel was respectful of the earlier architecture, including the plastered walls, sculpted quality, and crafted detailing. The project achieved a Leadership in Energy and Environmental Design (LEED) Gold Level Certification, which demonstrates that it is energy-efficient and environmentally conscious. (Mark Boisclair Photography, Desert Star Construction.)

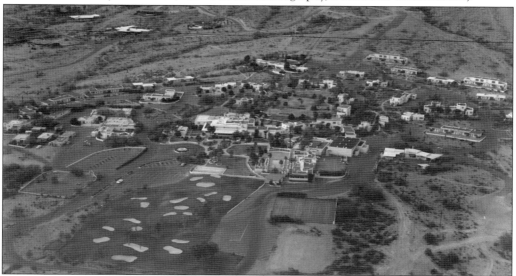

CAMELBACK INN. This aerial view shows a cactus-studded oasis of 125 acres for 200 guests. The 1936 seasonal resort was constructed at a time when there were no lights, telephone, or water on-site. It did feature 75 tiny casitas, a glass-enclosed swimming pool, horseback riding, and two tennis courts. The designer, Edward Loomis Bowes, settled in the area in 1920 for his wife's health. He was an engineer, furniture designer, and photographer who graduated from Washington University in St. Louis. (Scottsdale Public Library.)

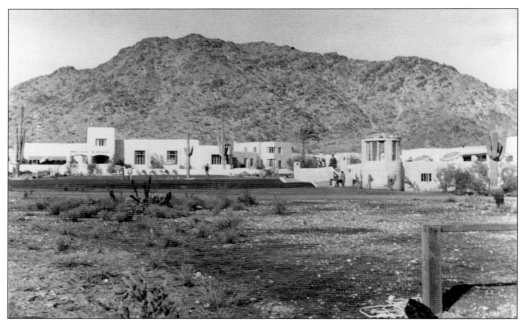

CAMELBACK INN, 1936. John C. Lincoln and Jack Stewart jointly invested to create a destination resort at 5402 East Lincoln Drive and started marketing to affluent travelers in the upper Midwest. The adobe architecture conveyed a southwestern Pueblo Revival character. A series of outdoor patios and courtyards and an inviting casual ambiance presented this desired character. The inn was annexed into the town in 1983. (Scottsdale Historical Society.)

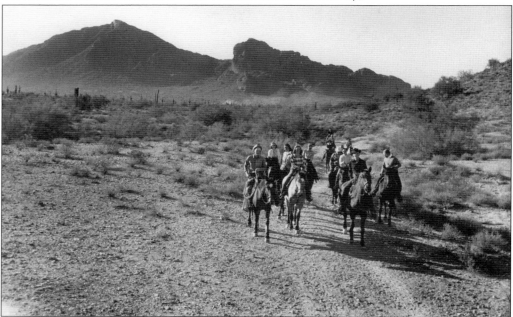

CAMELBACK INN, C. 1930s. This view of Camelback Inn shows guests on horseback with Camelback Mountain as the backdrop. Other recreational activities included swimming, tennis, and desert picnics. (Scottsdale Public Library.)

JACK STEWART. The original manager of the Camelback Inn was Jack Stewart, pictured here on horseback, who was in a partnership with John C. Lincoln, president of Cleveland Electric Company. Stewart sold the venerable resort to J.W. Marriott in 1967. (Scottsdale Public Library.)

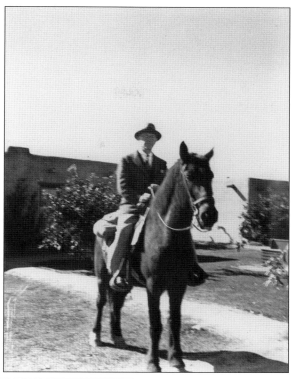

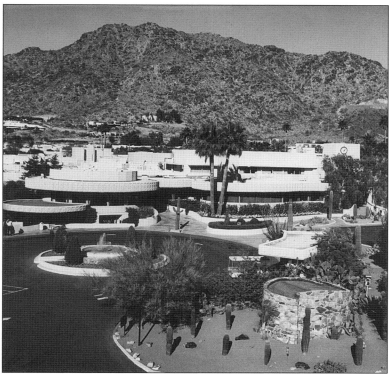

CAMELBACK INN. Marriott expanded the property to 453 rooms and added a world-class spa in 1989. This image shows the additions that were completed later. The inn continued to use its original slogan: "Where time stands still." (Verner Wulf, AIA, Phoenix Metro Chapter.)

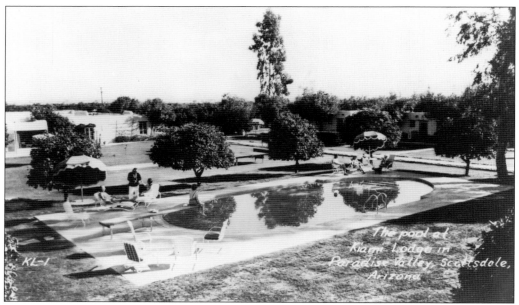

KIAMI LODGE, 1937. A 10-acre guest ranch was developed within a citrus grove on the west side of Scottsdale Road. The Indian style was reflected in the interior décor, furniture, artifacts, and fine art. Artist Charles Loloma painted murals and graphics there. (Scottsdale Historical Society.)

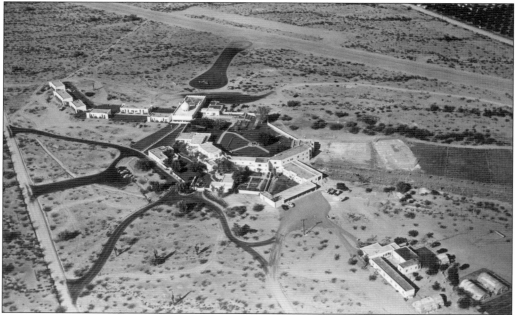

CASA BLANCA INN, 1944. The 1924 Donald Kellogg residence at 5101 North Sixty-sixth Street was purchased in 1944 by George Borg of Borg Warner Company in Delavan, Wisconsin. In 1946, Borg opened the Casa Blanca Inn with 30 rooms for 80 guests, a private landing strip for small planes, stables, swimming pool, putting green, shuffleboard, and tennis. Eighteen additional rooms were added in 1948. Royal Treadway leased it from Borg in 1952 and bought it in 1961. (Scottsdale Historical Society.)

HORSE SHOW, C. 1945. This image shows Larry Walton riding "Colonel Wood" at a horse show on the Tennessee Walking Horse Ranch, owned by Capt. Tom Hog, which later became Mountain Shadows East. Mummy Mountain is in the background. (Robert Markow, Beth Wickstrom.)

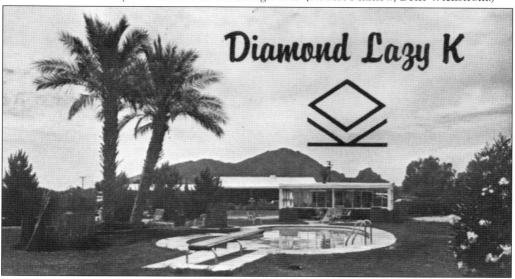

DIAMOND LAZY K RANCH. In 1957, this five-acre resort was located at 7100 East Lincoln Drive and featured 26 bungalows managed by owner Karl Bailey Johnstone. The advertisement states: "You are cordially invited to be a guest Sun-Aire at Diamond Lazy K . . . where moments make memories. Play badminton, shuffleboard court, putt your choice of two greens, swim, hike—or just laze around in the knock-about togs. Do anything that pleases you, in warm sunshine mixed with exhilarating dry desert air." It was named Smoke Tree Resort in 1962. (Author's collection.)

CASA VERDE GUEST LODGE. The lodge at 6730 East McDonald Drive provided a swimming pool and sun-drenched patios, with a golf course and saddle horses nearby. Individual guesthouses included a kitchen and lodge, hosted by the Haydens. (Author's collection.)

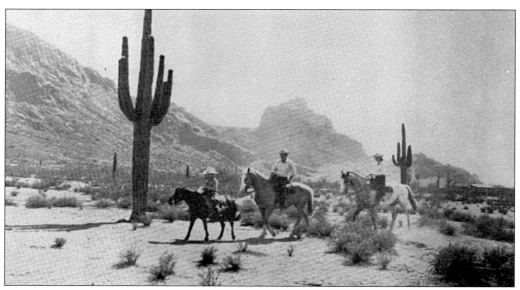

FLYING 'T' RANCH. The 1951 Ranch on East Lincoln Drive offered four *ranchitos* and a swimming pool with an underwater observation window. The owner was Frank S. Tilyou; the ranch closed in the 1960s. (Author's collection.)

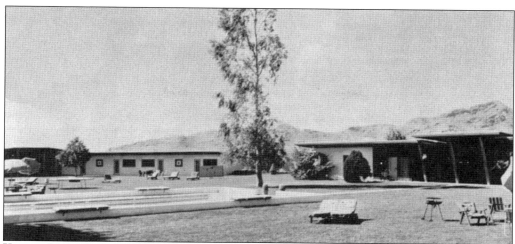

YELLOW BOOT RANCH, 1953. This ranch was located five miles north of Scottsdale at 6726 East Doubletree Road. "Picturesque Resort Apartments all with kitchenettes, surrounding a green oasis on the sunny desert in the heart of Paradise Valley. Quiet, away from traffic, yet only eight minutes from town. Beautiful unobstructed view, large heated pool, shuffleboard court, central lounge. A friendly place for friendly people to relax and can accommodate 30 guests." The resident owners were Bob and Louise Balch. (Bob Balch, Tom Silverman.)

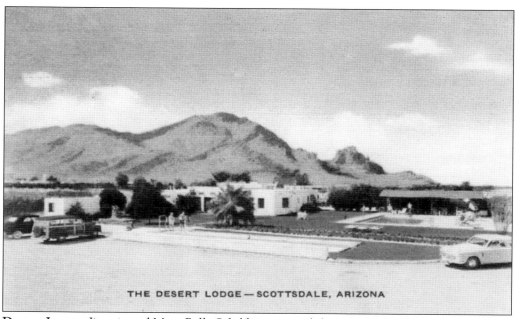

THE DESERT LODGE — SCOTTSDALE, ARIZONA

DESERT LODGE. Jimmie and Mary Belle Schildman turned their own 1940s home at 6167 North Invergordon Drive into the Desert Lodge and offered guests the "American or European Plan." A shuffleboard court, golf course, and heated pool were the amenities provided. In 1968, the property was purchased by the new Calvary Church of the Valley. (Associated Desert Lodges.)

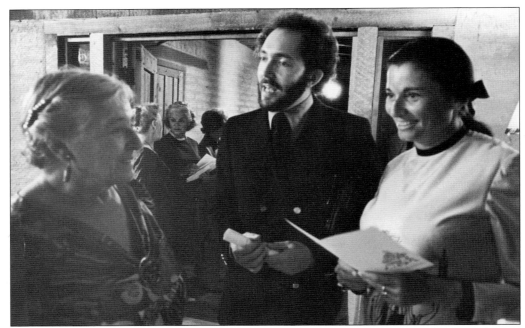

KERR CULTURAL CENTER. Musician and philanthropist Louise Lincoln Kerr (right) hosted many events at her namesake Kerr Cultural Center. The center is located at 6110 North Scottsdale Road, where a 1943, one-story Spanish Colonial Revival–style house stands. In 1959, a 210-seat studio addition was constructed; later, another addition was designed by architect Fred Fleenor. The center, now owned by Arizona State University, has served as an intimate venue for visual and performing artists over the years. (Scottsdale Historical Society.)

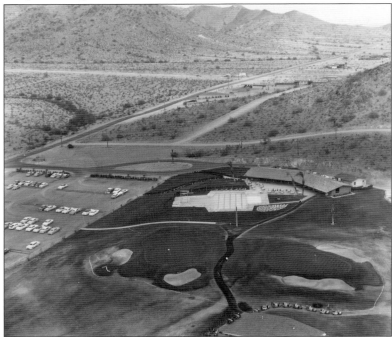

PARADISE VALLEY COUNTRY CLUB, C. EARLY 1950S. This aerial view of the 270-acre Paradise Valley Country Club shows the first phase of construction with the ranch-style homestead and the 1953 18-hole golf course designed by Lawrence Hughes. (Scottsdale Historical Society.)

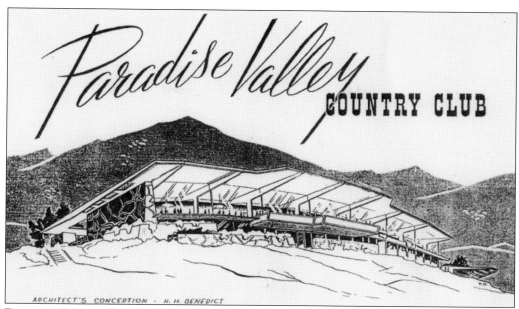

PARADISE VALLEY COUNTRY CLUB, 1953. A second phase of construction was managed by architectural firms Edward L. Varney Associates, AIA, and Hiram Hudson Benedict. Designer Dean Rendahl of Varney's office was also responsible for the Phoenix Country Club and Moon Valley Country Club of this same era. The rendering was by architect Hiram Hudson Benedict. (Paradise Valley Country Club.)

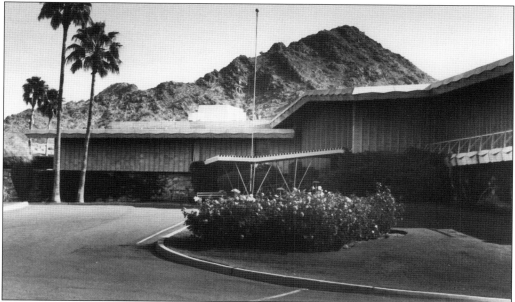

PARADISE VALLEY COUNTRY CLUB, 1953. Located at 7101 North Tatum Boulevard, this private club was initiated by investors and community leaders. The main two-story structure was constructed of natural stone, concrete block with vertical precast concrete inserts, tall glazing, and cantilevered overhangs faced with a decorative, precast concrete panel. The property was annexed into the town in 1984. (Edward L. Varney Associates, AIA.)

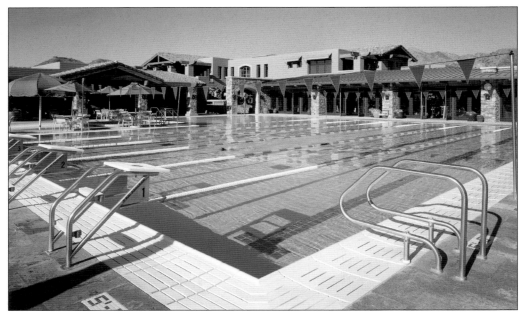

PARADISE VALLEY COUNTRY CLUB, 2004. In 2002, the original structure was demolished to construct a new, eclectic country club for its membership designed by Swaback Partners, PLLC. Major reconstruction involved two phases of construction, completed in 2003 and 2004. (Swaback Partners, PLLC.)

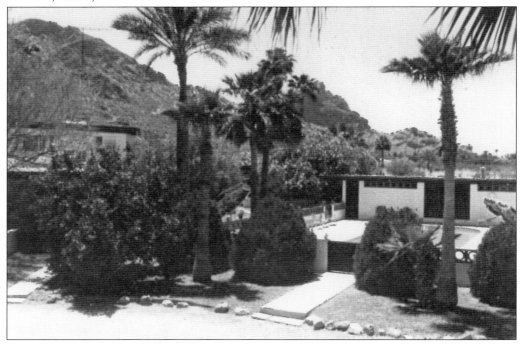

SHANGRILA RESORT, C. 1960S. This resort was quaint and small-scale, with one-story structures focused on a swimming pool and desert landscaping. It was removed later for a new, large residence. (Scottsdale Historical Society.)

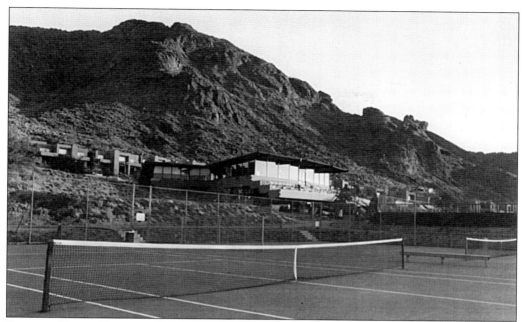

PARADISE VALLEY RACQUET CLUB, 1957. This 53-acre development at 5600 East McDonald Drive was comprised of a clubhouse, studio cottages surrounding the clubhouse, five tennis courts, dining room, cocktail lounge, dance floor, recreation room, and a swimming pool. Hollywood investors included John Ireland, Joanne Dru, and Sydney Chaplin, Charlie Chaplin's son. (Scottsdale Historical Society.)

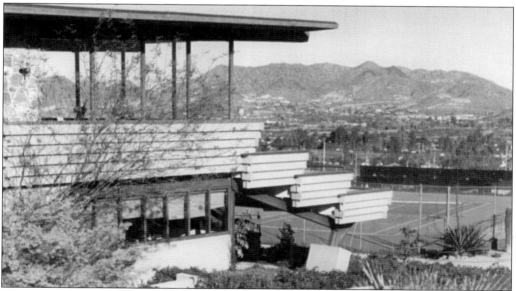

PARADISE VALLEY RACQUET CLUB, C. LATE 1950S. The design was similar to the Racquet Club of Palm Springs. Natural materials included exposed concrete block, horizontal plank siding, and recessed window glazing. The architect was Hiram Hudson Benedict, who was also active in Scottsdale and Cave Creek, Arizona, and San Diego, California, during the 1950s and 1960s. (Scottsdale Historical Society.)

PARADISE VALLEY RACQUET CLUB. The club served as a backdrop for this model photograph session. Note the natural stone wall details and horizontal wood plank siding above. (Associated Desert Lodges.)

JOHN GARDINER'S TENNIS RANCH, 1969. The original Paradise Valley Racquet Club became the John Gardiner's Tennis Ranch in 1969. Investors Vic Jackson and Les Heitel constructed 41 hillside rental casitas designed by the architectural firm Benedict and Caviness. The ranch hosted many celebrity tennis tournaments and attracted tennis professionals like Pancho Seguero, Ken Rosewall, and Pancho Gonzalez. The ranch was most active from 1969 to 1992 and closed in 2000. (Allen + Philp Architects/Interiors.)

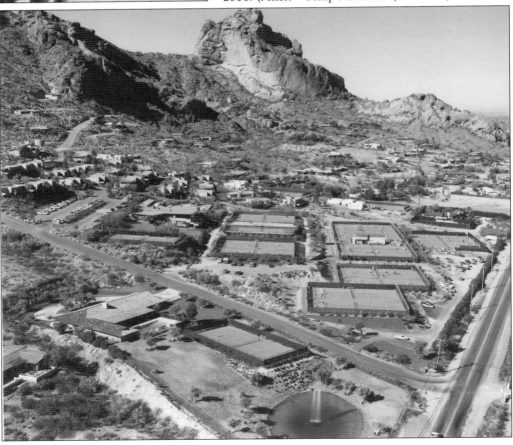

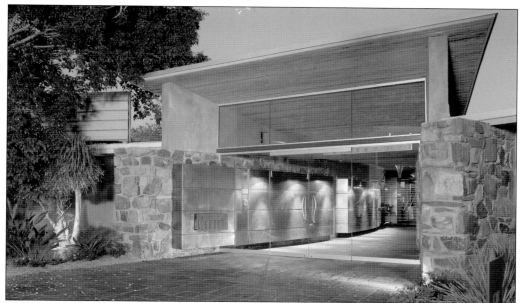

SANCTUARY ON CAMELBACK MOUNTAIN, 2001. The original John Gardiner's Tennis Ranch was renamed The Ranch on Camelback Mountain and then the Sanctuary on Camelback Mountain. The 53-acre sanctuary was redesigned and master-planned with 82 remodeled casitas, 12 home sites, a negative-edge swimming pool, spa, fitness center, and the Elements Restaurant, with its entry shown here. The architect was Allen + Philp Architects/Interiors. (Allen + Philp Architects/Interiors.)

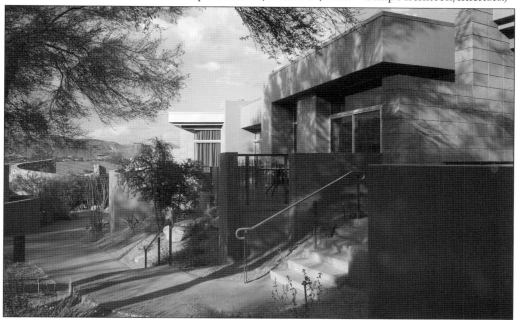

SANCTUARY ON CAMELBACK MOUNTAIN, 2001. Twenty-four new spa villas spill down the hillside, accessed by pleasant pedestrian walkways, and framing dramatic views of Paradise Valley beyond. The original tennis courts were used to develop these suites and the spa, fitness center, and pools. (Allen + Philp Architects/Interiors.)

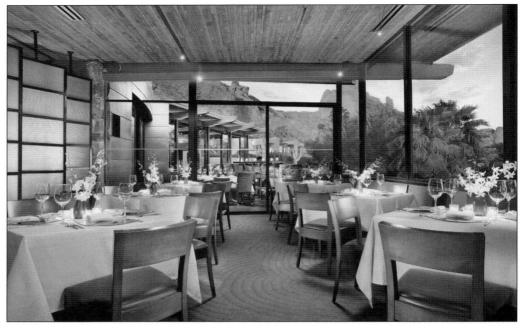

SANCTUARY ON CAMELBACK MOUNTAIN, 2001. The Elements Restaurant interior saved the original glazing and exposed wood ceiling and maintained the Camelback Mountain "Praying Monk" and sunset views to the west. Restaurant interior designer Judith Testani worked with architect Allen + Philp Architects/Interiors. (Allen + Philp Architects/Interiors.)

SANCTUARY ON CAMELBACK MOUNTAIN, 2001. The spa suite interior has a character that is intimate, refreshing, romantic, and contemporary, with bold accent colors and textures. This design approach helped reposition the iconic tennis resort into a spa and fitness-based experience. (Allen + Philp Architects/Interiors.)

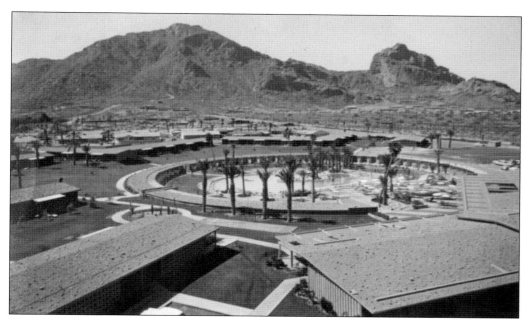

MOUNTAIN SHADOWS RESORT, 1959. Located at 5641 East Lincoln Drive, this 55-acre resort development was created by developer Jim Paul. The year-round resort was defined by 100 guest rooms initially and was surrounded by an executive 18-hole golf course designed by Arthur Jack Snyder. The architecture captured the post–World War II era with sweeping guest wings, full-height glazing, and a large courtyard with an expansive swimming pool, green turf, and palm trees. (Scottsdale Historical Society.)

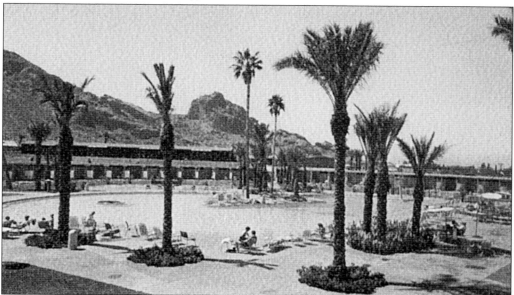

MOUNTAIN SHADOWS RESORT, 1959. Jim Paul sold 50 percent of the resort to Del Webb Corporation in 1961 and the remaining half in 1964. Surrounding the resort were 59 lots in two single-family subdivisions. The resort was purchased by Host Marriott Corporation in July 1981 and closed in 2004. The popular resort had a relaxed and sophisticated ambiance. (Scottsdale Historical Society.)

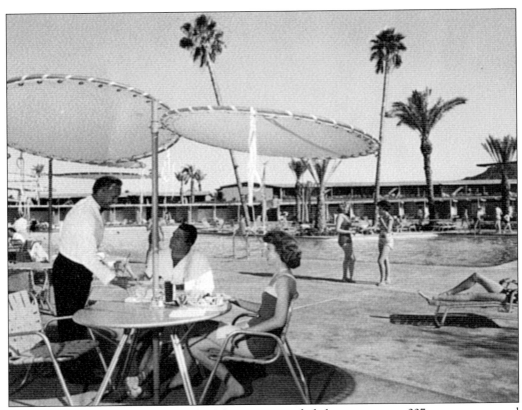

MOUNTAIN SHADOWS RESORT, 1959. Marriott expanded the property to 337 guest rooms and added dining options, eight lighted tennis courts, three swimming pools, a sand volleyball court, a fitness center, and meeting space for 10 to 1,000 people. The resort site was eventually annexed into the Town of Paradise Valley in 1992. (Scottsdale Historical Society.)

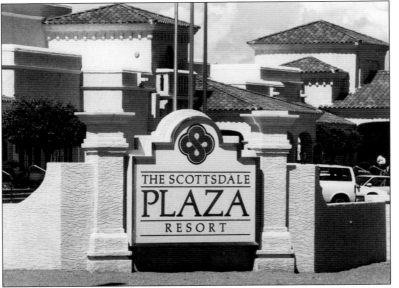

SCOTTSDALE SHERATON RESORT, 1975. Spanish Colonial Revival-style resort at 7200 North Scottsdale Road was later renamed Scottsdale Plaza Resort. The architecture includes textured plaster walls, arched openings, broken rooflines, clay tile roofs, small-paned windows, and an oasis-like landscape. (Scottsdale Historical Society.)

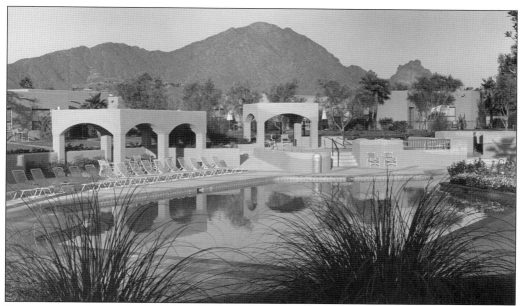

RENAISSANCE COTTONWOODS RESORT, 1980. At 6160 North Scottsdale Road, a resort opened originally as the Alamos Resort Hotel that included 223 hotel rooms and suites, 24 cabana casitas, 34 luxury villas, a spa, restaurant, and grand ballroom. Structures were made of plastered walls and had flat-arched features and stepped forms to reduce the scale. The architect was Bennie Gonzales Associates. (Scottsdale Historical Society.)

LOEW'S PARADISE VALLEY RESORT, 1984. The resort at 5401 North Scottsdale Road later became a Wyndham and Hilton Doubletree. Buildings exploit custom-formed masonry units that provide deep shadow patterns, thereby self-shading and cooling the walls in this hot climate. Shaded arcades knit together the building components and courtyards. (Author's collection.)

CAMELBACK GOLF CLUB, 2000. The golf course at 7800 North Mockingbird Lane was initially developed for Camelback Inn guests on a 200-acre parcel. The Padre Course, with 18 holes, was designed by Red Lawrence initially, redesigned by Arthur Hills, and renamed the Resort Course. In 2007, it reverted back to its original Padre name. The original 1969 golf club structure was demolished and a new clubhouse was built in 2000. The Pueblo Revival style uses plastered walls and smaller window openings. (Author's collection.)

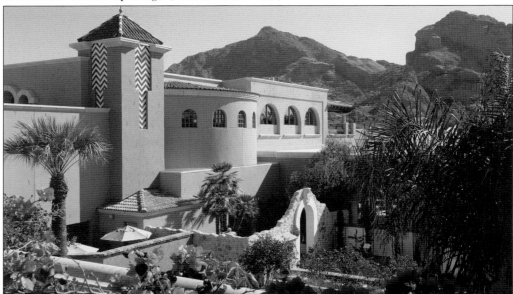

MONTELUCIA RESORT AND SPA, 2010. The former 1978 La Posada, Red Lion, and Doubletree Resort property received a major, 285,000-square-foot expansion and redevelopment that provided 293 hotel rooms, 34 luxury residences, a spa, a renovated wedding chapel, and four swimming pools. The overall plan respected the original dry washes and celebrated the character of a Spanish Andalusian village with plastered walls, accent colors, detailed iron grills, shaded arcades, and a series of courtyards. The architect was Allen + Philp Architects/Interiors. (Allen + Philp Architects/Interiors.)

Five

RELIGIOUS EXPRESSIONS: 1950–1990

As the Paradise Valley area population grew in the 1950s and 1960s, a desire for religious facilities also grew. A number of congregations were founded years earlier outside the current town boundaries. They would rent movie studios, Quonset huts, credit union basements, resorts, and galleries. Some had difficulties finding space to rent given their beliefs and felt the need to construct new facilities. During this time, some larger land parcels were gifted or acquired by the different organizations, given that they were relatively affordable and could accommodate the growing congregations.

Without exception, each of the congregations found very creative architects to implement their respective visions. Barney "Bennie" Gonzales, FAIA, was most prolific with having been responsible for the design of the 1961 Gloria Dei Lutheran Church, 1966 Har Zion on the Desert, 1966 Scottsdale Bible Church, and 1967 Christ Church of the Ascension. Other talented architects included T.S. Montgomery for the 1961 Episcopal Parish Saint Barnabas on the Desert, who was also responsible for many other local church designs. Blaine Drake, a successful disciple of Frank Lloyd Wright, designed the 1961 First Unitarian Universalist Church of Phoenix and numerous other churches in the area. Harold Wagoner, a Philadelphia architect, designed the 1958 Valley United Presbyterian Church and was also responsible for over 500 church designs nationally.

The vast majority of such religious campuses in Paradise Valley have grown with additional programs, services, and structures over the past 50 years. The Town of Paradise Valley adopted in November 1976 a special use category for memorial gardens on religious properties.

Each religious structure and outdoor space strived to express its congregation's beliefs and visions in a meaningful way. The interior lighting, finishes, furnishings, artifacts, and stained glass panels have provided contemplative retreats and inspiration over the years.

By the 2000s, the Town of Paradise Valley had 14 churches and houses of worship.

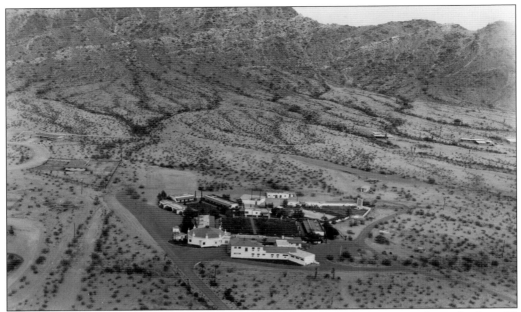

FRANCISCAN RENEWAL CENTER. A former Echo and Kachina Lodge guest ranch was built on 20 acres that could accommodate 70 guests at 5802 East Lincoln Drive. The lodge was purchased by John B. Mills, operator of the Hotel Westward Ho, and G.C. Callerman, a Chicago food broker. They sold the lodge in 1951 to the Franciscans of St. Barbara Province, who adapted it to the Franciscan Renewal Center or Casa de Paz y Bien, which means House of Peace and Good. Friar Owen De Silva envisioned the center to be a place with spiritual appeal, where people would "come apart into a desert place." (Scottsdale Historical Society.)

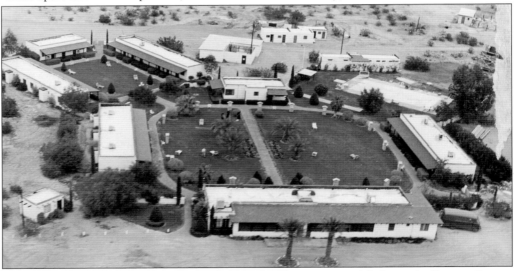

FRANCISCAN RENEWAL CENTER, 1952. The main building was remodeled into the Retreat Center, and the first retreat was held January 14, 1952. A new chapel broke ground soon thereafter on June 19, 1954. In 1955, approximately five acres were acquired just west of the main property. The original 20 acres continues to be a Maricopa County island within the town. (Franciscan Renewal Center.)

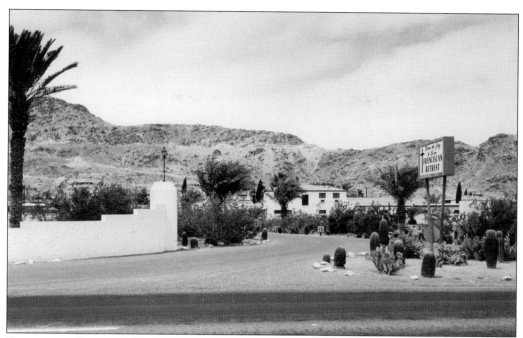

FRANCISCAN RENEWAL CENTER.
This is the view north of Lincoln
Drive after the Franciscan
Renewal Center sign was erected
on Lincoln Drive in the 1950s.
(Scottsdale Historical Society.)

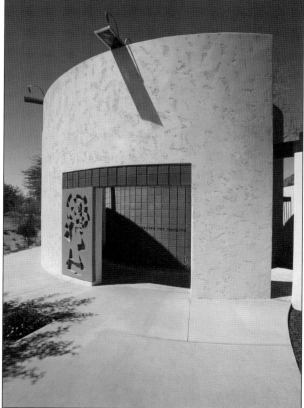

SAINT CLARE CHAPEL, 2004.
Located at 5808 East Lincoln
Drive, a chapel dedicated to Saint
Clare (whose name means light)
was added to the Franciscan
Renewal Center. The chapel was
designed for quiet meditation
and expressed Franciscan ideas
of connection and mystery.
The architect was Colab Studio
LLC. (Timmerman Photography
Inc., Colab Studio LLC.)

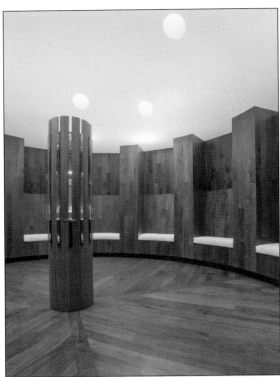

SAINT CLARE CHAPEL, 2004. Art and architecture utilize Arizona's abundant sunlight. Existing stained-glass panels were reused atop the outer wall as colored and patterned shadow makers. A plaster relief of St. Clare adorns the entrance to the 250-square-foot chapel. The interior is clad in solid walnut with seats carved into the walls to strengthen one's connection to the space. (Timmerman Photography Inc., Colab Studio LLC.)

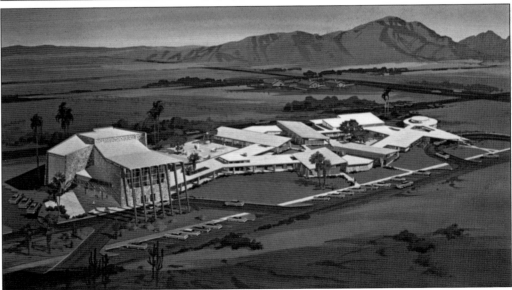

VALLEY PRESBYTERIAN CHURCH, 1958. This church was established March 18, 1956, with 70 charter members and first met in the Desert Art Gallery and School. The church purchased five acres, followed by an additional five acres. Within two years it had 700 members and architect Harold E. Wagoner of Philadelphia proposed this design. In 1958, the new education spaces, office buildings, and Landes Hall (on the right) were built at 6947 East McDonald Drive. (Petley Studios, Flora M. Swanson, Valley Presbyterian Church.)

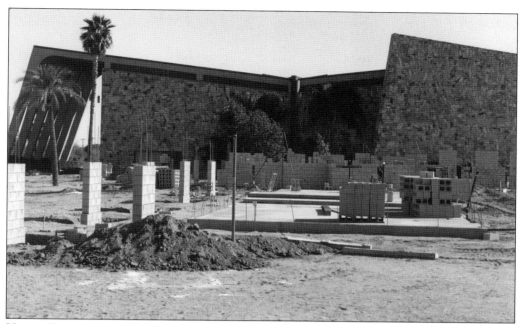

VALLEY PRESBYTERIAN CHURCH, 1976. The congregation worshipped in Landes Hall until 1966, when the 800-seat sanctuary was built. This view shows the sanctuary beyond and the "connecting link" under construction in 1976. The sanctuary was constructed of massive cast-in-place concrete beams for the roof structure and tall bearing walls of stone from the Prescott area. (Flora M. Swanson, Valley Presbyterian Church.)

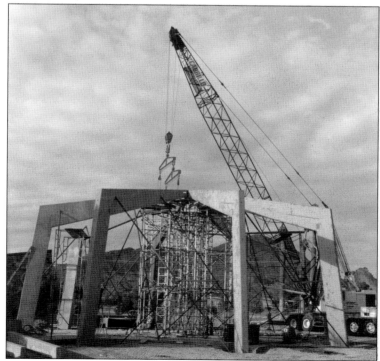

VALLEY PRESBYTERIAN CHURCH, 1983. A round chapel with radiating concrete beams and upper stained glass panels by space artist Robert McCall was then constructed and completed in 1983. The structure was staged for a future steeple, which was built a few years later. (Flora M. Swanson, Valley Presbyterian Church.)

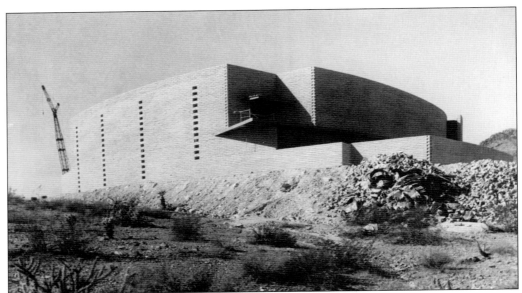

FIRST UNITARIAN UNIVERSALIST CHURCH OF PHOENIX, 1961. This church was founded in 1947, with lines to the 1620 Pilgrim Church founded in Plymouth. Here, construction is well underway with curved and exposed slump block walls. Cantilevered from the walls are thin-profiled shade canopies at the entry and upper windows. The smaller windows will admit dappled light to the interior, while minimizing the heat from this severe exposure. (Unitarian Universalist Congregation of Phoenix.)

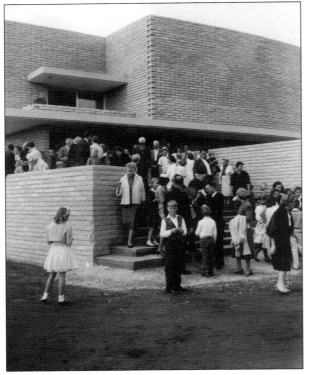

FIRST UNITARIAN UNIVERSALIST CHURCH OF PHOENIX, 1961. In the late 1950s, this congregation acquired a nine-acre parcel at 4027 East Lincoln Drive for a new campus. They intended to commission Frank Lloyd Wright, but he passed away in 1959. Architect Blaine Drake, a disciple of Wright, was then approached and provided the project. An approximately 19,000-square-foot structure was built and included an elliptical sanctuary and a curved classroom wing focused on an outdoor courtyard. (Unitarian Universalist Congregation of Phoenix.)

BIRMINGHAM STATUARY, 2003. This statuary is located at the Unitarian Universalist Congregation of Phoenix campus. The 1963 bronze sculpture plaque reads: "That Which Might Have Been. Birmingham 1963. Symbolizing the unfulfilled maturity of the four girls killed in the church bombing in Birmingham, Alabama, September 15, 1963. Dedicated to the understanding of the beauty of individual difference. John Henry Waddell." This particular event marked a turning point in the 1960s Civil Rights movement and contributed to support and passage of the 1964 Civil Rights Act. (Author's collection.)

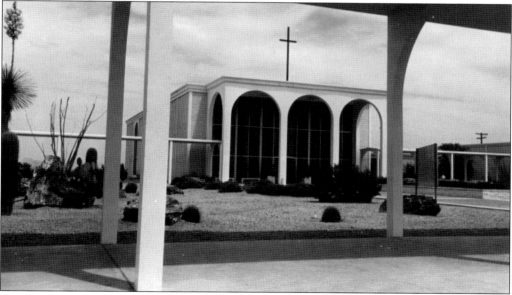

THE EPISCOPAL PARISH OF SAINT BARNABAS ON THE DESERT, 1961. This parish started in 1953 and met at a downtown Scottsdale Quonset hut. The church was built at 6715 North Mockingbird Lane and was designed by architect T.S. Montgomery. The exterior walls were a mortar-washed slump block and pitched roof forms. A shaded arcade connected multiple buildings on this campus. The overall scale of its various components and between the buildings is elegant and well proportioned. Fowler and Anne McCormick and Anne's son Guy Stillman were early patrons and congregation members. (Scottsdale Historical Society.)

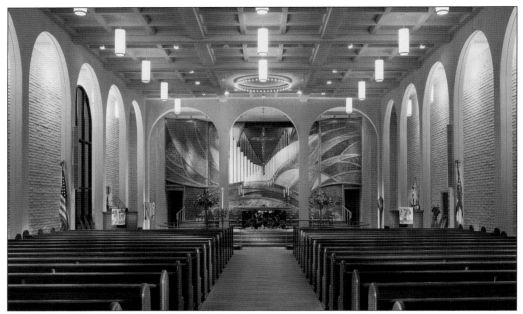

THE EPISCOPAL PARISH OF SAINT BARNABAS ON THE DESERT, 2003. This interior view of the renovated main sanctuary reflects sensitivity for the original ambiance despite integrating a new organ. Original indirect light sources have been maintained and continue to provide a visual depth to the contemplative space. The original interior was outfitted by artists Allen Ditson and Lee Porzio. The renovation architect was Knoell & Quidort Architects. (Dino Tonn Photography, Knoell & Quidort Architects.)

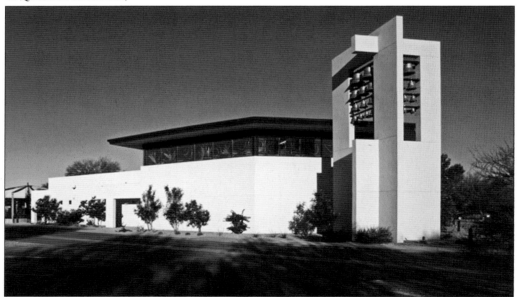

THE EPISCOPAL PARISH OF SAINT BARNABAS ON THE DESERT, 2003. An addition included a new music hall, library, offices, and coffee shop designed by Knoell & Quidort Architects. The addition is a contemporary interpretation of the original off-white plaster walls, while introducing natural daylight from above and into the interior spaces. (Richard Maack, Knoell & Quidort Architects.)

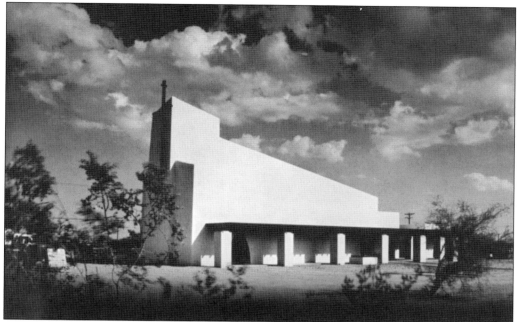

GLORIA DEI LUTHERAN CHURCH, 1961. This church, located at 3539 East Stanford Drive, is constructed of slump block walls that are given a painted mortar wash. This technique creates a rubble texture that plays well in the intense southwestern light, self-shades the wall surface, and minimizes the heat gain during the hotter summer months. Bennie M. Gonzales, FAIA, was the architect. (B.J. Gonzales.)

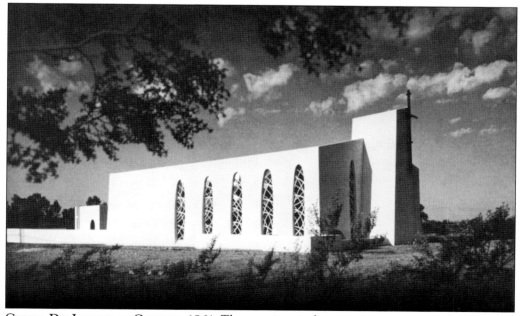

GLORIA DEI LUTHERAN CHURCH, 1961. The exterior window openings were created with wood-frame formwork when laying the surrounding block. The formwork was then removed, and custom stained glass panels inserted. The church provides Bible study and classes. (B.J. Gonzales.)

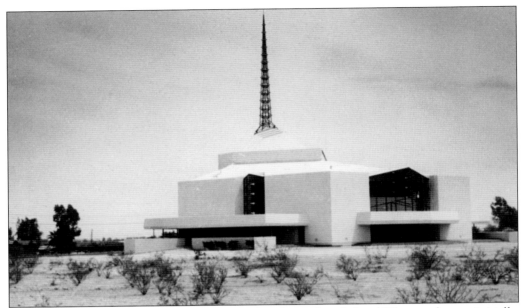

ASCENSION LUTHERAN CHURCH, 1963. This church was founded in 1951, rented space initially, and then built its first church in downtown Scottsdale in 1952. Membership grew, and they purchased 10 acres at 7100 North Mockingbird Lane. The church continues to be open to community activities and as a polling place. Taliesin Associated Architects designed the church, with William Wesley Peters as the architect of record. (Scottsdale Historical Society.)

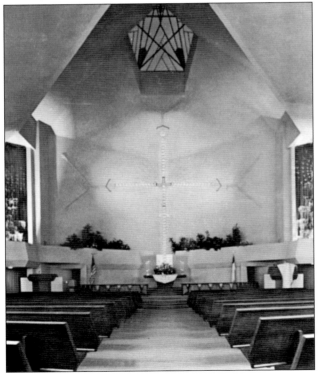

ASCENSION LUTHERAN CHURCH, 1966. The pentagon was considered a perfect geometric figure by Frank Lloyd Wright, reflecting the perfection of God. This theme is carried out in the worship center lights, altar rail, and baptismal font. The cross above the altar directs attention to the pentagon-shaped glass window above. (Ascension Lutheran Church.)

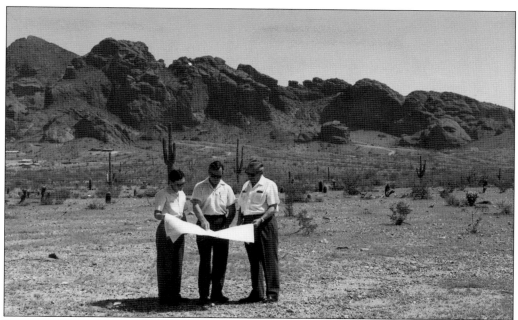

PARADISE VALLEY UNITED METHODIST CHURCH. The charter Sunday was December 18, 1960, with 83 members meeting at the Cudia City Motion Picture Studio and later at the Unitarian Church and Paradise Inn. A new church was planned at 4455 East Lincoln Drive on a 15-acre site. Architect Ralph Haver, FAIA, is shown here at center with church representatives, reviewing plans for the new church with Camelback Mountain in the background. Haver Nunn and Jensen was the architect. (Paradise Valley United Methodist Church.)

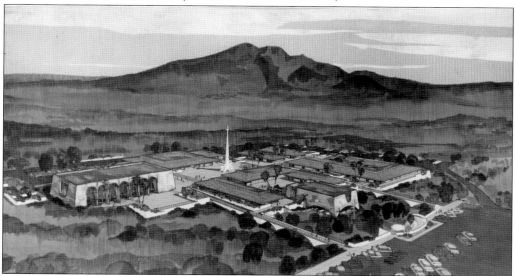

PARADISE VALLEY UNITED METHODIST CHURCH. An original rendering from an aerial view captures the proposed Paradise Valley United Methodist Church. The first phase shows the chapel and cluster of three office and classroom buildings defining a courtyard. A future phase included the sanctuary to the left. "The church as cultural center" was a priority for the congregation. (Paradise Valley United Methodist Church.)

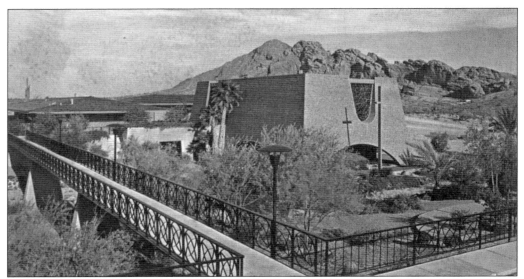

PARADISE VALLEY UNITED METHODIST CHURCH, 1964. Access to this church was from an elegant pedestrian bridge that spanned a dry wash, which would flow periodically when it rained. The bridge is steel-framed and painted with a concrete deck. (Paradise Valley United Methodist Church.)

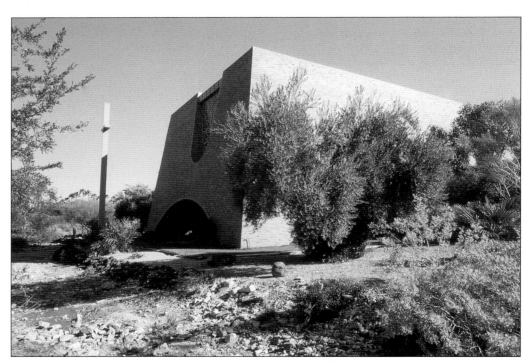

PARADISE VALLEY UNITED METHODIST CHURCH, 1982. A taller 1964 chapel with battered brick walls anchors itself to the wash banks and the courtyard. The leaded stained glass altar window was designed by Jim Salter and fabricated by the Glassart Studio of Scottsdale. One-story structures have low pitched roofs of wood shakes, cantilevered edges, recessed brick walls, and protected glazing. (Author's collection.)

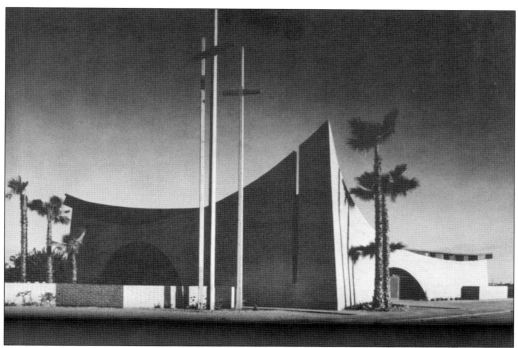

SCOTTSDALE BIBLE CHURCH, 1966. This Church moved and its building was purchased in 1979 to become Temple Solel, a Reform Synagogue, after that congregation initially met at Camelback United Presbyterian Church. The synagogue is located at 6805 East McDonald Drive and sponsors several events during the year along with adult education classes. The architecture is very expressionistic, with the large arched window and sweeping roof line. Bennie Gonzales, FAIA, was the architect. (Scottsdale Historical Society.)

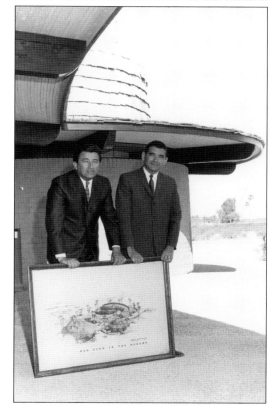

HAR ZION ON THE DESERT, 1966. The full-service conservative synagogue of the United Synagogues of America was at 5929 East Lincoln Drive and offered kindergarten through second grades and a Hebrew School for third through eighth grades. The architecture was a series of interlocking curved walls with a floating shake roof canopy above. The image is of the architect Bennie Gonzales, FAIA, with his client. The structure was demolished and a custom home was constructed on the site. (Scottsdale Historical Society.)

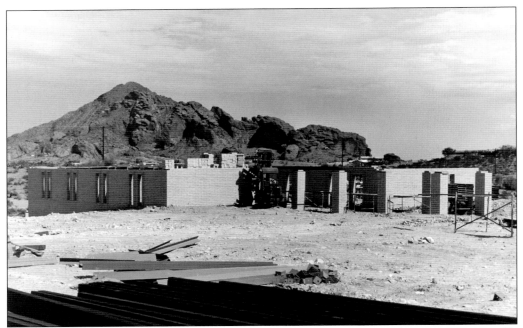

THE EPISCOPAL PARISH OF CHRIST CHURCH OF THE ASCENSION, 1967. The congregation initially met at a film studio, Phoenix Country Day School, and a First Federal Savings and Loan. The 4015 East Lincoln Drive campus is 8.25 acres, provided with a warranty deed by Margaret "Peggy" Goldwater Trust, half of which was a gift from the Goldwater family. The first phase parish hall, temporary worship area, office, and classrooms, designed by architect Bennie Gonzales, FAIA, are pictured under construction. (Robert T. Marvin, Christ Church of the Ascension.)

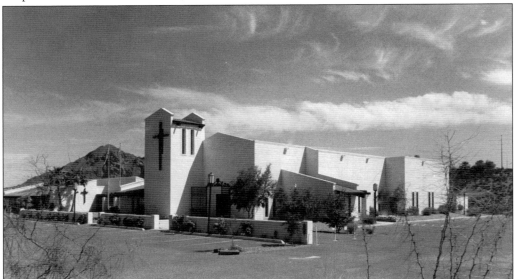

THE EPISCOPAL PARISH OF CHRIST CHURCH OF THE ASCENSION, 1975. The main church was built in 1975, and a school for pre-kindergarten through first grade was built in 2003. The character of the main sanctuary was respectful of the earlier parish hall, using similar masses, pitched roofs, mortar-washed slump block walls, and white color. (Christ Church of the Ascension.)

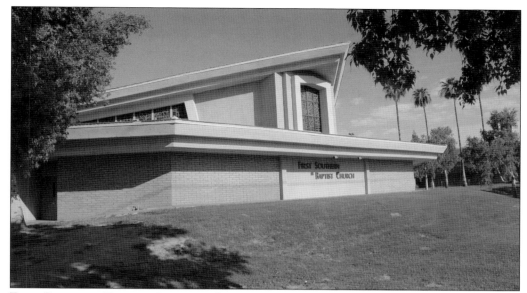

FIRST SOUTHERN BAPTIST CHURCH. The original site was the 1924 Kiami Lodge, and until the mid-1980s, one adobe building still remained. The lodge swimming pool still remains under the existing volleyball court. The church acquired the property in 1968, followed by two construction phases in 1972 and 1980, both designed by architect William A. Lockard. The final phase was the 1989 sanctuary by architect Norman Bryar and Associates Inc. and provided a pitched roof with cantilevered edges and recessed masonry walls. Lower structures are flat-roofed with wood shake mansards. (Author's collection.)

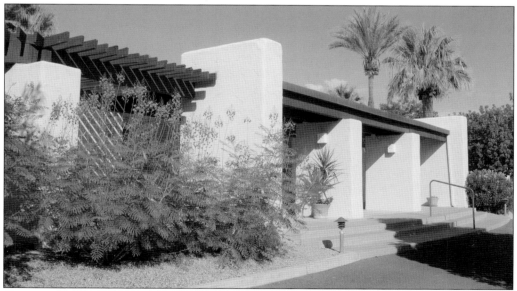

CALVARY CHURCH OF THE VALLEY. At 6107 North Invergordon Road, the original c. 1940s Desert Lodge became the 1968 church that offered youth activities, Bible studies, local outreach, and overseas and local missions. Structures reflect the use of bearing plastered block walls and piers that support a wood-frame trellis. Occupied spaces are deeply recessed under the roof, thereby cooling them during hotter times of the year. (Author's collection.)

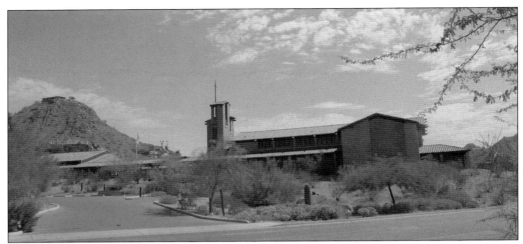

ALL CHRISTIAN FAITHS, 1969. The church at 4222 East Lincoln Drive was constructed in phases, starting with the north component and shaded arcades. They defined an exterior courtyard and then accepted the main sanctuary expansion. Exterior walls are a burnt adobe, with roof framing of heavy wood members, and stained glass work by Maureen McGuire. The first church had financial challenges and was sold to its current owners, Friends Bible Church. The architects were Dellisanti and McGrath. (Author's collection.)

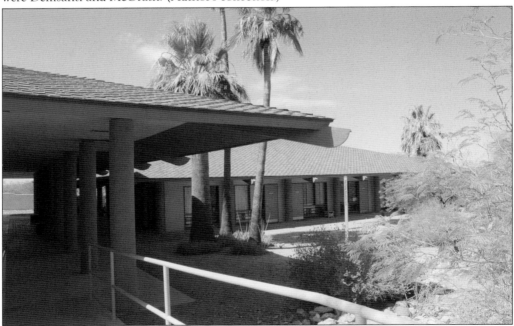

CAMELBACK UNITED PRESBYTERIAN CHURCH, 1983. The church at 3535 East Lincoln Drive was founded with 216 members and has grown to 300. They have shared the facilities with other religious organizations, including the Sunrise United Presbyterian Church. In 1987, the name changed to the Palo Christi Presbyterian Church. The architecture utilizes a pair of pavilions with perimeter-shaded walkways capped with large pitched roofs of wood shakes. It provides flexibility when accessing the interior spaces, making it conducive to sharing the buildings with others. The architect was Harry Youngkin, AIA. (Author's collection.)

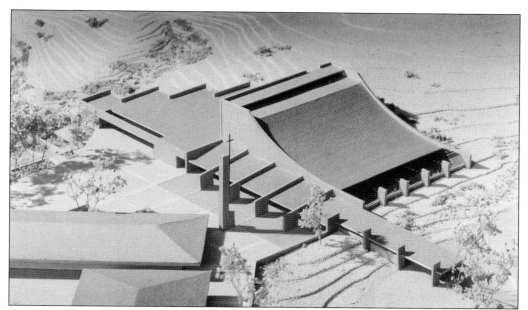

PARADISE VALLEY UNITED METHODIST CHURCH SANCTUARY, 1982. The original architect's model shows a 500-seat sanctuary addition to an existing campus and how it provided a new identity to the community. Knowing that the architect took an extensive tour of Finnish architect Alvar Aalto's work at this time, some overtures to Aalto's work are unmistakable, such as the use of brick, sweeping roof form, bell tower, horizontal shaded arcade, and the spatial dynamic of rotating the interior seating within the building shell. George Christensen and Associates was the architect. (Paradise Valley United Methodist Church.)

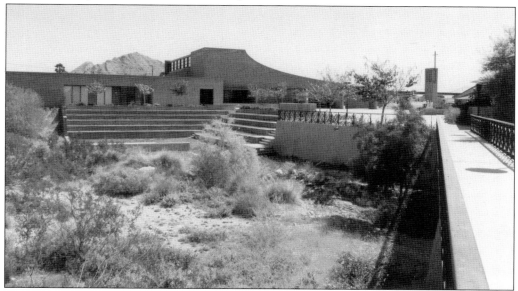

PARADISE VALLEY UNITED METHODIST CHURCH SANCTUARY, 1983. The view from the original pedestrian bridge to the new sanctuary addition shows an outdoor stepped amphitheater that connects the new upper plaza to the existing dry wash below. Christensen, Roberts & Jones Inc. was the architect. (Paradise Valley United Methodist Church.)

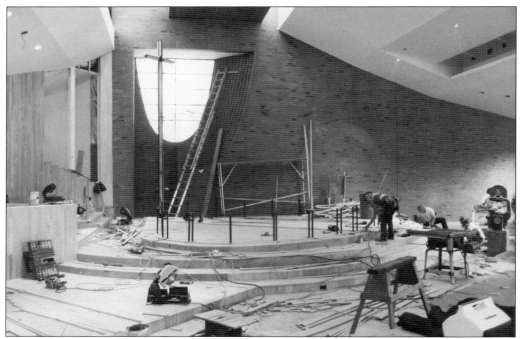

PARADISE VALLEY UNITED METHODIST CHURCH SANCTUARY, 1983. Exterior brick is carried into the interior of the sanctuary. Note how the lighter colors psychologically open up the volume. The clerestory above admits and reflects daylight, while focusing attention on the future stained glass art piece by Maureen McGuire. (Paradise Valley United Methodist Church.)

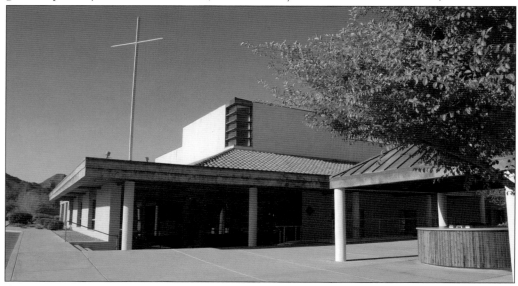

CAMELBACK BIBLE CHURCH. This independent, evangelical church organized in 1962 and purchased 10 acres for a new church at 3900 East Stanford Drive. The 1,000-seat 1988 sanctuary design reflects a more contemporary interpretation, with the use of plastered block walls, green-patina copper roof and fascia, and horizontal corner windows. The architect was TMP and Associates with Maurice Allen of Bloomfield Hills, Michigan. (Author's collection.)

Six

DOMESTIC ENCLAVES: 1915–2012

Starting in the 1920s, cowboy artist Alonso "Lon" Megargee III designed adobe homes in Paradise Valley, such as the 1926 Casa Del Sol and the 1930 Casa Hermosa. Both are a creative blend of Pueblo and Spanish Colonial Revival styles.

Many adobe structures of the 1930s and 1940s were built by several Mexican families, such as the Tomas Corrals, who came here from Mexico to work as farm hands, given the demand for cotton after 1914. In 1932, the Mexican Bernals family supervised the Edward Jones house construction on Casa Blanca Drive, with help from Salt River Pima-Maricopa Indian Community workers.

The post–World War II era brought about expansive growth with an aesthetic preference for a Ranch style character, which used low-pitched outreaching roofs, exposed concrete masonry units, and board and batten walls and tall glazing to capture views.

The 1970s were an active time for various new Paradise Valley ordinances impacting residential projects, including the 1972 Hillside Ordinance that enforced an unbroken mountain profile and a natural appearance. In June 1975, outdoor lighting restrictions limited lighting heights and shielded lights, helping to preserve nighttime views.

During the early 1980s, new large homes started displaying an encyclopedic diversity of architectural character that was beginning to threaten the quiet desert ambiance, which had been the goal of earlier decades. "These houses are a kind of cartoon to everyone with any knowledge of how people live with the desert and take care of their environment," said architect Calvin C. Straub, FAIA, in 1983. Architect Paul C. Yaeger stated at the same time, "these houses are totally out of place. They reflect none of the ruggedness of the mountains or the simplicity and smoothness of the desert." Despite such justified criticisms, many local, nationally recognized, and talented architects have created inspiring residential designs in Paradise Valley over time.

A new, single-family subdivision was developed at the southwest corner of Invergordon and Lincoln Drive. It proposed building a wall at the subdivision perimeter, a new concept that was much debated in the community. This guarded and gated community established a new pattern of residential development and compromised the earlier open spaces found between homes. In March 2003, Paradise Valley's General Plan noted that "gated communities [would] be discouraged." By the 2000s, there were 24 gated communities and 50 organized home owners' associations.

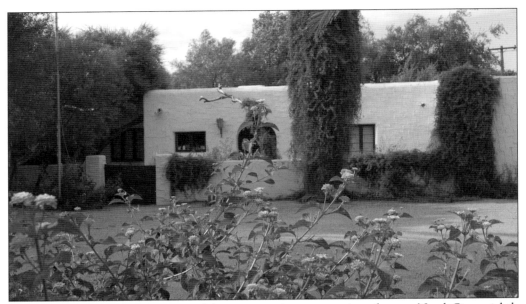

FARM RESIDENCE. A 1915 one-story adobe structure sits among a citrus farm on North Sixty-eighth Street, now within the Arcadia Square no. 2 subdivision. The Pueblo Revival–style, 1,818-square-foot home incorporates three patios, a two-car garage, and an L-shaped exterior stair for access to the roof. Details include arched openings with French doors, high-beamed ceilings, original decorative iron light fixtures, and curtain hardware. (Author's collection.)

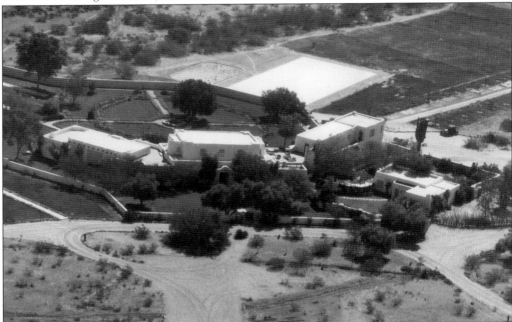

DONALD KELLOGG RESIDENCE, 1924. Robert T. "Bob" Evans was the original architect of the residence at 5101 North Sixty-sixth Street. The large home was of plastered adobe construction in the Pueblo Revival style. A series of outdoor patios and courtyards were integrated; it was an effective experiment in how to live in the lower Sonoran Desert. (Scottsdale Historical Society.)

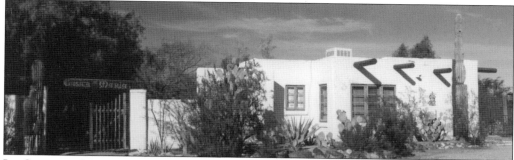

LA CASITA DE MARIA. On North Camino del Contento, three c. 1925 structures totaling 3,850 square feet were built around a courtyard. The one-story, Pueblo Revival–style structures were originally part of a guest ranch. There remains a palm shrine and two Madonna bas-reliefs as testament to the spiritual character of the original builders. The buildings later underwent an award-winning restoration and became a single-family residence. (John Douglas Architects.)

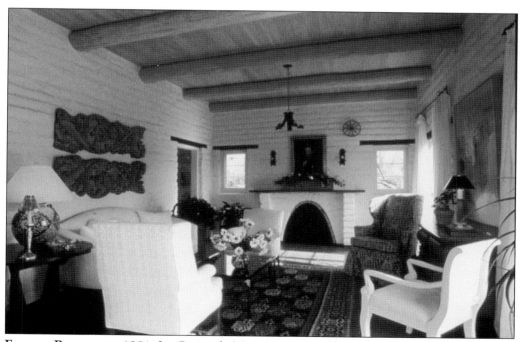

FRIEDER RESIDENCE, 1991. La Casita de Maria's courtyard became part of the living space, while mature landscaping, the well house, and a fountain were restored. A new swimming pool was carefully inserted into an existing prickly pear cactus thicket. Floors were integrally dyed red concrete, ceilings were of clear fir with raw pine pole beams, and exterior stucco was dyed brown. The architect was John Douglas, FAIA, and the landscape architect was Christy Ten Eyck, FASLA. (John Douglas Architects.)

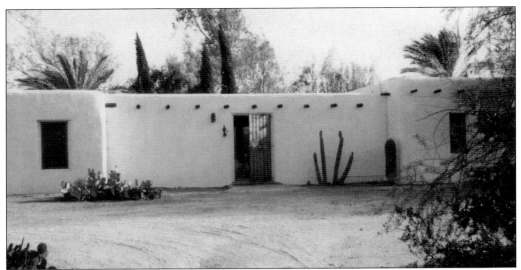

ADOBE RESIDENCE, 1969. This c. 1928–1930 residence is located on East McDonald Drive. Its 3.2 acres included a main residence, three guest casitas, a common kitchen, a coachman's house, one-car garage, breezeways, an outdoor room, and an observatory for stargazing. A cluster of structures defined an expansive courtyard with sundried bricks, wall vines, and shade trees. One-story structures reflect the Pueblo Revival style with plastered walls, small-paned windows, and wood vigas. The architect was Robert T. "Bob" Evans. (Bruce Berquist.)

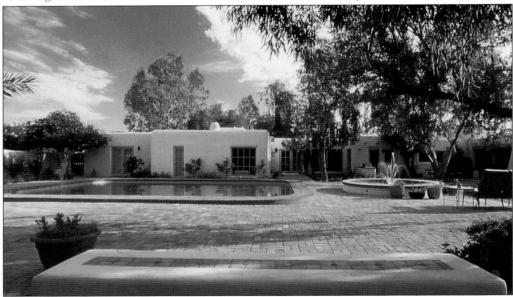

POWERS RESIDENCE, 1991. This adobe residence underwent an award-winning building restoration and courtyard upgrades by architect John Douglas, FAIA, and landscape architect Christy Ten Eyck, FASLA. Structures were stabilized and repaired, and had their original color brought back. The original courtyard was completely reworked for better drainage, the swimming pool was upgraded, some trees were removed to enable entertaining, and it continued to capture the east-west breezes. The design reflects a "real yearning to live with the desert," as stated by the owner and architect. (John Douglas Architects.)

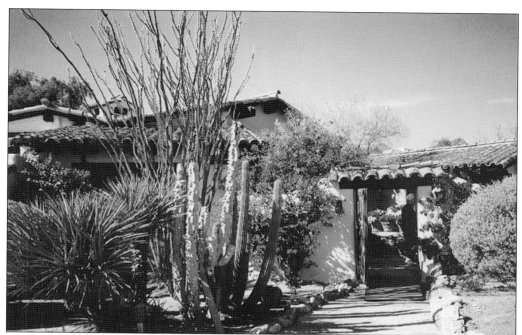

CASA DEL SOL. Cowboy artist Alonzo "Lon" Megargee III designed and constructed a 3,500-square-foot adobe Spanish Colonial and Pueblo Revival–style home on 15 acres in 1926 for his wife, Mildred. The one-story home, with a partial second-level artist studio and outdoor courtyard, was upgraded later by new owners Benner/Maas, founding principals of the Scottsdale-based interior design firm. (Pat VanVelser Heard.)

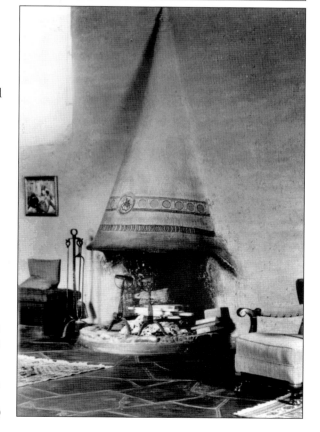

CASA DEL SOL, 1926. The living room has a whimsical, cone-shaped fireplace topped with a Santa Claus that defined and animated the tall space. The room had an exposed wood-frame ceiling and roof structure above. (Betsy Fahlman, Pat VanVelser Heard.)

PRINGLE RESIDENCE. Sisters Mildred and Bertha Pringle lived in this 1930s one- and two-story adobe residence on a large parcel at North Casa Blanca Drive. It was later sold to the Firestone family. It is rumored that they managed an unlicensed tuberculosis health camp at the home. The Pueblo Revival style incorporates smaller window openings and light-colored plaster walls. (Author's collection.)

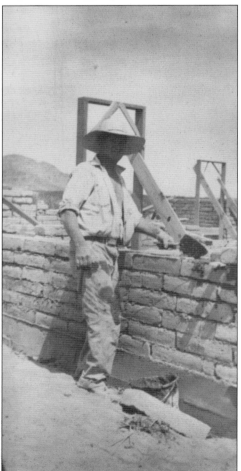

DUNCAN MACDONALD. Originally from Invergordon, Scotland, Duncan MacDonald was proud of his Scottish heritage. He worked as a skilled plasterer whose creations adorned public buildings of his time. Projects included the Palace West Theater and the Security Building in Phoenix. McDonald Drive was named after Duncan MacDonald, but the spelling of his name was changed in the process, and it was never corrected on the maps. (Scottsdale Historic Society.)

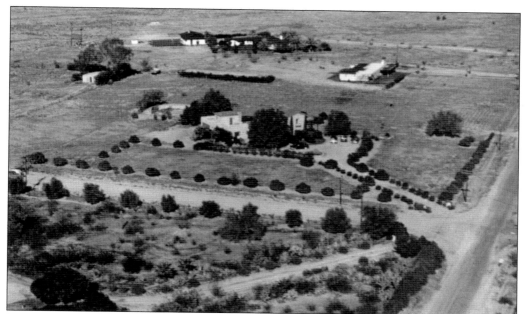

MacDonald Residence, c. 1930s. This is an aerial view of a large adobe home at 6330 East McDonald Drive. Duncan MacDonald designed and constructed this adobe residence in a Spanish Colonial and Pueblo Revival style. (Earl Eisenhower, Elsa J. Rector.)

MacDonald Residence, c. 1930s. It is said that the floor plan was dictated by the desired interior furniture arrangement. The home was sold to John C. Lincoln, an Ohio industrialist who brought his family to this area in the early 1930s. The Lincoln family lived in the home for many years. (Scottsdale Historical Society.)

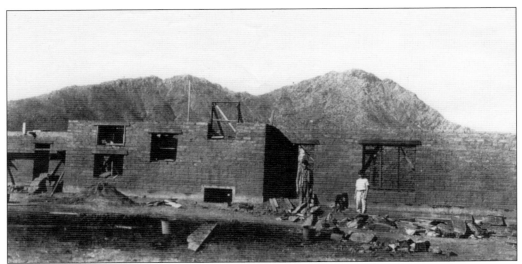

EDWARD JONES RESIDENCE, 1933. Ken Jones and his older brother are pictured with the adobe residence under construction. Adobe bricks were made of straw and soil sun-dried just east of the home. Once the walls were completed, they would be untouched for about one year, so they could structurally settle. They were then fully plastered and painted to discourage deterioration. Wood doors were constructed from salvaged redwood from the Verde Canal pipeline. (Ken Jones.)

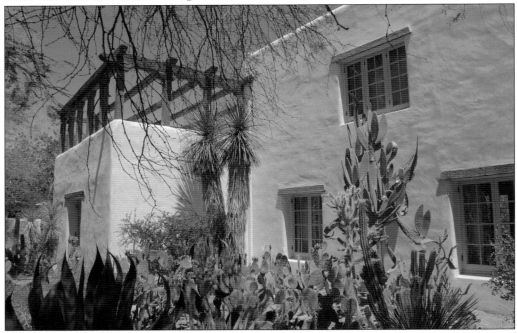

EDWARD JONES RESIDENCE, 2013. This 1933 adobe two-story home is a blend of Pueblo and Spanish Colonial Revival styles. The exterior doors and windows are intimate and scaled to be appropriate for this wall-like architecture. The original roof sleeping porch wood framing still remains. Located on North Casa Blanca Drive, it was once part of 50 acres sold to the Joneses by Edward Loomis Bowes. Jones then had citrus, date palms, and alfalfa fields, and raised turkeys on the property. His wife, May Jones, designed the home along with Bowes. (Author's collection.)

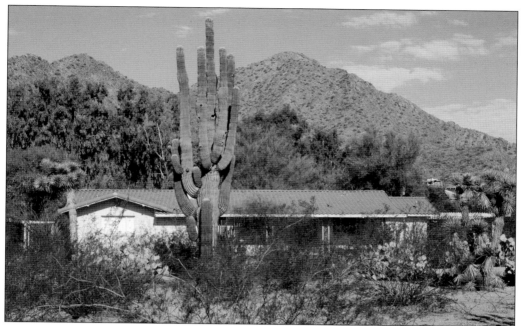

HENRY WICK RESIDENCE. A 1939, one-story Pueblo Revival–style home is located on North Casa Blanca Drive. The plan was L-shaped, with an outdoor stair, plastered walls, and metal casement windows. The residence was designed by Denver Evans, architect Robert T. "Bob" Evans's son. (Author's collection.)

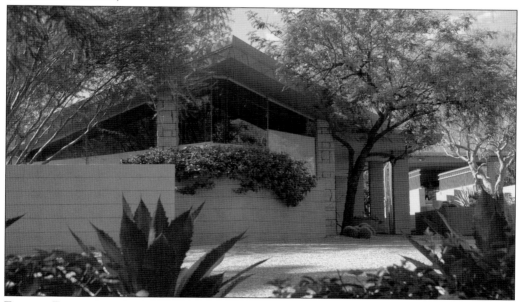

FENNELL RESIDENCE, 1955. The 5,962-square-foot Mike Fennel residence is located on East Prickly Pear Lane and was designed by architect Charles Montooth of Frank Lloyd Wright Associates. The home incorporates dramatic cantilevered roof forms with patterned fascia, an arcaded entry breezeway, and a two-car carport. Materials include natural stone, exposed concrete masonry units, and tall clear glazing. (Author's collection.)

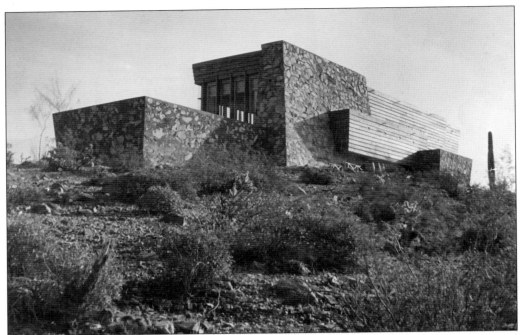

PAUSON RESIDENCE, 1941. This custom winter residence was a natural extension of the hillside and its topography. The vertical structure explored desert masonry masses that were interlocked with shifting, wood-framed horizontal elements. Frank Lloyd Wright was the architect. (Janie Ellis.)

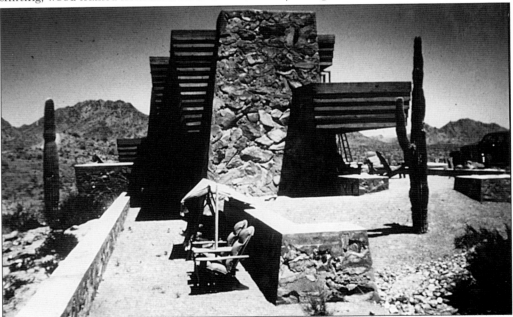

PAUSON RESIDENCE, 1941. The plan included a balcony, studio, and servants' quarters. The fireplace location was debated, and an ember actually caught the draperies on fire in 1943, thereby destroying the entire residence. The house was constructed by George Ellis at a cost of $7,500. (Janie Ellis.)

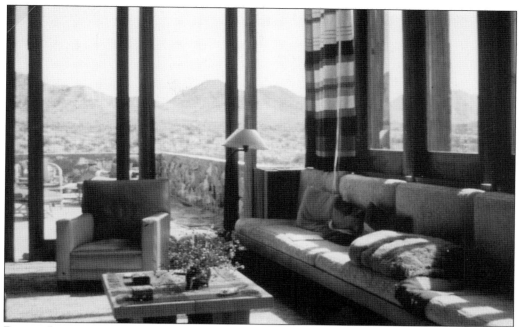

Pauson Residence, 1941. Interior spaces extended to the exterior, and a series of outdoor terraces overlooked the views beyond. (Janie Ellis.)

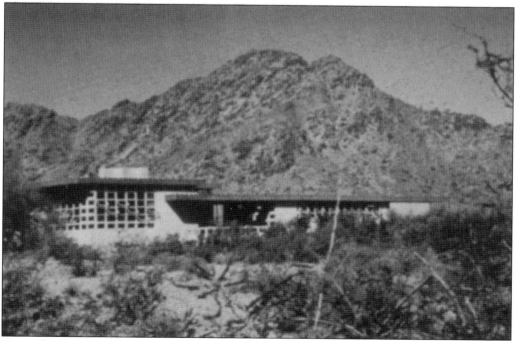

Peiper Residence, 1952. This residence is on East Cheney Drive but has been seriously altered with additions and remodels over the years. The home, designed by Frank Lloyd Wright, reflects his approach to a Usonian Automatic block system, which is when the blocks are cast on site and are therefore more affordable. (Frank Lloyd Wright Foundation, AIA Phoenix Metro.)

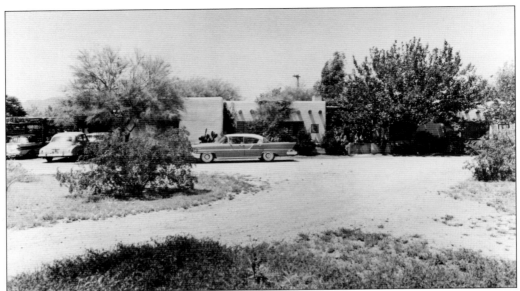

Rancho Lucero, 1951. This East Berneil Lane residence's roof was framed with wood beams from an old sawmill near Showlow, Arizona, and *vigas* or log beams from nearby McNary. The exterior walls were left in their natural state, but suffered damage during storms, so they were fortified with stucco. The property also had a carport, rose garden, horse corrals, a haystack, chicken house, alfalfa field, and a well. (Jamey and Linda Cohn.)

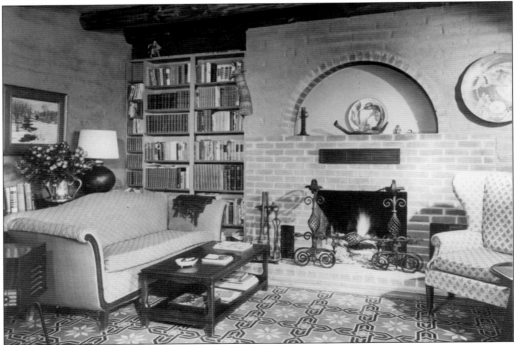

Rancho Lucero, 1951. The floor tiles were made in Nogales, Sonora. All interior adobe walls were "liberally and repeatedly sealed with skim milk. All windows opened to unspoiled, uninhabited desert in their day." (Jamey and Linda Cohn.)

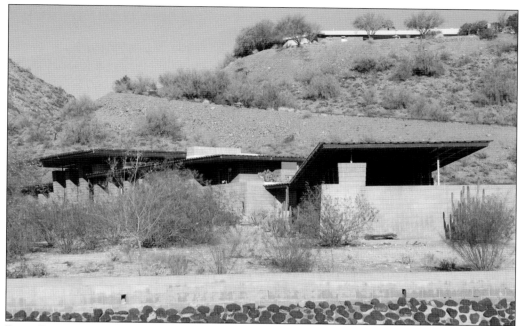

PRICE RESIDENCE, 1954. Harold C. Price Sr.'s winter residence, by Frank Lloyd Wright, is located on North Tatum Boulevard. The plan has two wings in an angular relationship to each other, connected by an open loggia that captures the breeze, has a fountain, and is supported by tufa block columns that form inverted cones. The southwestern section includes the dining, living, kitchen, and guest rooms, the maids' quarters, and a carport. The east wing has five bedrooms and bathrooms. Low profile flat roofs float over four different floor levels and continuous glazing. (Author's collection.)

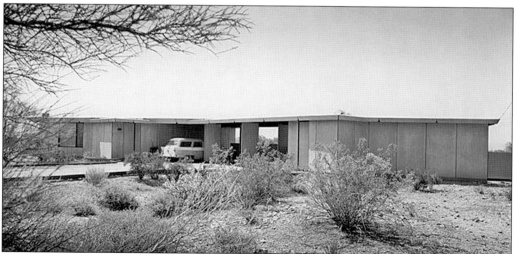

THEODORE F. WASHBURN RESIDENCE, 1955. This bachelor's residence on East Stanford Drive provided a main house, guest quarters, triple carport, and a round swimming pool. The one-story wood-frame structures have a flat roof that was influenced by a Japanese theme of high-quality simplicity. The view shows the north and west elevations. The architect was Blaine Drake; years later, it was remodeled by Alfred Newman Beadle. (Alison King.)

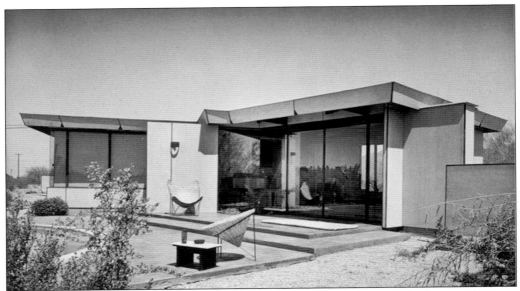

THEODORE F. WASHBURN RESIDENCE, 1955. This view shows the partial south elevation. Exterior walls included a grey Flex board with cantilevered soffits above to protect the glass. Interiors use mahogany panels, a ceiling of blonde tongue-and-groove planks, and tan concrete floors. (Alison King.)

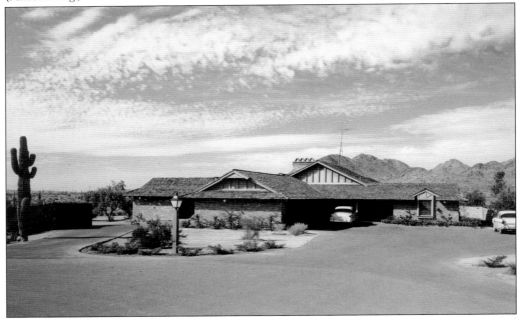

MADISON RESIDENCE, 1955. Mr. and Mrs. Gray Madison's 3,357-square-foot residence was located on a 1.48-acre property at East Pepper Tree Lane and the east edge of the Paradise Valley Country Club. Madison owned a local car dealership and was a co-founder of the club. The house exhibits the Ranch style, with pitched wood shake roof and brick walls. The architect was Fredrick Weaver, and Dick Drover was the designer. (August Beinlich Photography, DWL Architects & Planners Inc.)

HOLCOMB RESIDENCE. The Adm. Harold R. Holcomb residence was constructed in 1956 at East Lincoln Drive. Holcomb was a retired rear admiral in the Navy, was active in World War I and II, and served as a justice of the peace in Scottsdale. The residence used exposed and soldier stacked block, low-pitched roof, corner windows, a dynamic entryway with a rotated carport, and a minimalist fireplace. The original architect was Blaine Drake. (Author's collection.)

GOLDWATER RESIDENCE, 1957. US senator Barry Goldwater's hilltop residence has a low, horizontal profile with natural stone retaining walls, deeply recessed glazing, and cantilevered pitched roof overhangs with a thin edge. The home had an appropriate character for desert living, was held tight to the natural topography, and framed dramatic views of Camelback Mountain and city lights. Within the home was a ham radio station. The architect was Paul Christian Yaeger. (Bill Sears.)

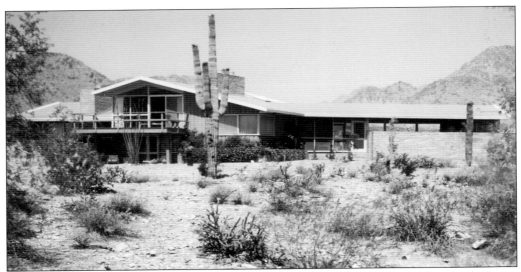

SCHAFFNER RESIDENCE, 1957. This Mid-century and Ranch-style home is located at North Quartz Mountain Road and was a split-level plan for a bachelor and his guests. It is sited at a 30-degree angle to take advantage of the winter sun and the best views overlooking the Paradise Valley Country Club golf course. Paul Christian Yaeger was the architect. (Beth Wickstrom.)

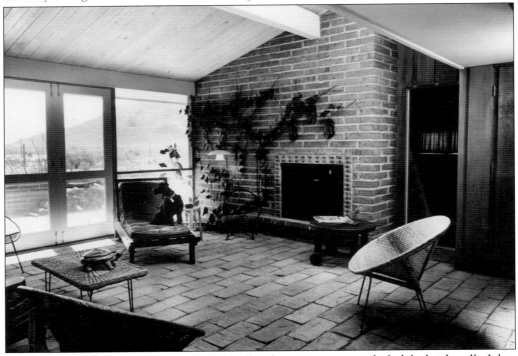

SCHAFFNER RESIDENCE, 1957. The John Schaffner home is constructed of adobe brick walls. It has a heavy, beamed construction with hemlock ceilings. The second level offers a panoramic view of Paradise Valley through framed glass partitions. There are a number of patios and an exterior deck that accessible from many different interior levels. The kitchen and lanai were top-lit with skylights. (Compton Photographers, Beth Wickstrom.)

KRAMLICH RESIDENCE. The 1960 Irv and Dorothy Kramlich Residence is located on one acre at North Desert Fairways Drive. The one-story, 4,752-square-foot residence has a semicircular floor plan that focuses on Camelback Mountain to the south. Walls facing the street are solid white plaster with colored glass inserts. An indoor swimming pool was added about 1966, followed by a 1997 remodel. Alfred Newman Beadle was the architect. (Realty Executives.)

O'CONNOR FAMILY. Sandra Day O'Connor and her husband, John, raised their three sons at this home on East Denton Lane. The O'Connors were very active in collecting petition signatures for potential incorporation of the Town of Paradise Valley. Former justice Sandra Day O'Connor was sworn in as the first female justice of the US Supreme Court on September 25, 1981, and retired on January 31, 2006. (Town of Paradise Valley.)

O'CONNOR RESIDENCE, 1958. The floor plan was rectangular with an angled end for the living room, an open kitchen, and a series of bedrooms along a hallway. A minimal palette of natural materials included bearing adobe walls, redwood window framing, a wood-framed roof with wood shake shingles, and red concrete floors. The character is more organic and casual, which fits the desert environment. The architect was Scottsdale-based Don K. Taylor. (Mark Vinson, FAIA.)

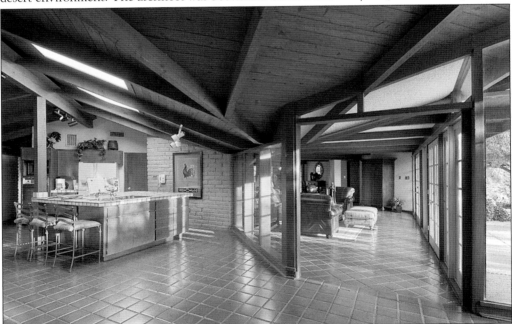

O'CONNOR RESIDENCE, 1958. The interior ambiance carries the exterior character and natural materials consistently throughout. Note the integral-colored concrete floors, exposed adobe walls, expressive roof structure, and generous window areas for introducing daylight. (Mark Vinson, FAIA.)

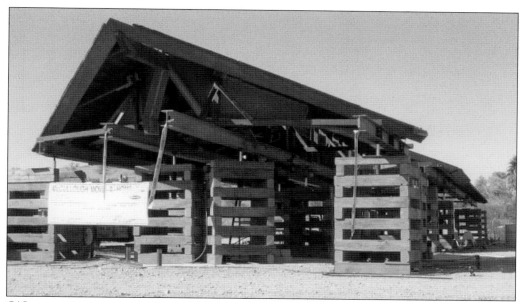

O'CONNOR RESIDENCE, 2010. In 2010, to avoid the threat of the home being torn down, the original house was dismantled and reconstructed at College Avenue and Curry Road in Tempe. The original adobe bricks were actually made at the nearby Salt River. This construction image shows the original roof being elevated and staged for laying the original adobe brick walls underneath. The completed building is being used as the O'Connor House and Center for Civil Discourse. Janie Ellis was instrumental in dismantling and reconstructing this fine home. (Mark Vinson, FAIA.)

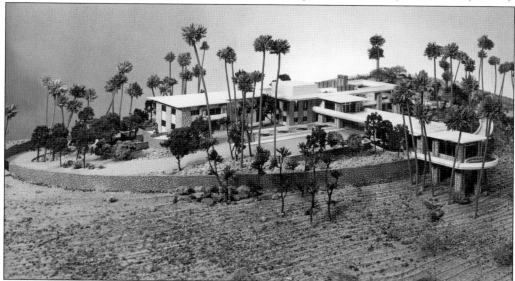

McCUNE MANSION, 1962. Walker McCune, an oil tycoon, Penzoil heir, and philanthropist, built a 40,000-square-foot estate on six acres on Sugarloaf Hill at North Paradise View Lane. Geordie Hormel owned the home later. The architecture was of commercial-grade construction with a concrete frame and precast concrete panels. Buildings were placed on an earth-filled plinth with a perimeter retaining wall. The architect was Stone, Marracini & Patterson with designer R.J. Bettencourt of San Francisco. (Scottsdale Historical Society.)

Douglas Driggs Residence, 1962. This residence was located at North Shadow Mountain Road and has been demolished. The home was a low-scaled exquisite jewel, connecting the interior spaces with a series of outdoor patios at differing levels and the Paradise Valley Country Club golf course. The manicured landscape was well known in this neighborhood. The architect was William F. Cody, FAIA, of Palm Springs, California. (Author's collection.)

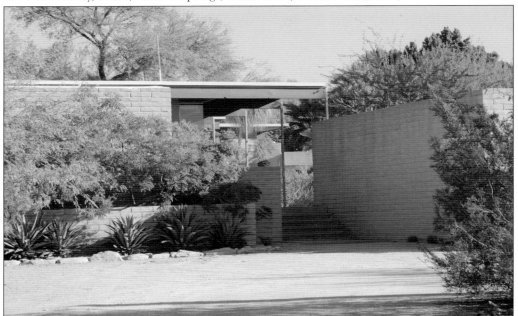

Manker Residence. Dr. Raymond Manker, a minister at the nearby Unitarian Universalist Congregation of Phoenix, had the church architect also design this 1964 home on East Pepper Tree Lane. The residence is 2,885 square feet and has five bedrooms and two bathrooms. One-story construction with an open carport includes slump block walls, steel columns, a wood-framed roof, and blue accent wall colors. The floor plan captured distant views and opened to an exterior patio. The architect was Blaine Drake. (Author's collection.)

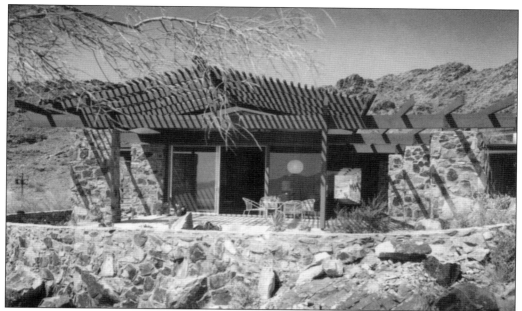

ANDEEN RESIDENCE, 1964. The Richard Andeen residence is located on North Hummingbird Lane. This award-winning and desert-sensitive piece provides site and building walls of exposed natural stone and a shade trellis of wood-frame members. Glazing is recessed into the thick walls, minimizing heat gain during the hot summer months. The landscape retained the original desert plantings and rock outcroppings. The architect was Straub/Kutch. (Neil Koppes, AIA Phoenix Metro.)

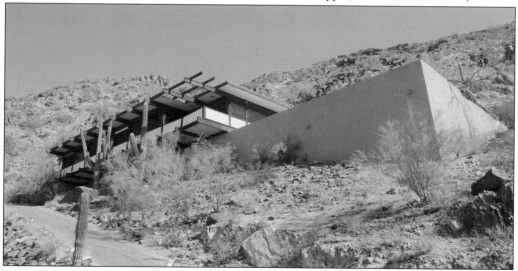

WEBER BACHELOR PAD. This East Glen Drive residence was built in 1966 and is set high on a south-facing hillside on Mummy Mountain with a one-acre property. The building form springs from the hillside, but is visually anchored by the plaster retaining wall that supports the swimming pool, which also extends into the living room. The 3,114-square-foot two-story home with three bedrooms is framed with exposed wood bent frames that shade the upper glazing. The influence of Frank Lloyd Wright's organic architecture is undeniable. The architect was Robert M. Lawton with Donald P. Woods Jr. (Author's collection.)

McDonald Residence, 2012. The Mr. and Mrs. Weir McDonald residence is located on North Tatum Boulevard and is a one-bedroom home with a private theater and two-car, open carport. The 1965 home steps down the rolling site with an exposed steel-frame structure and elevates many of the functions above the site. Site improvements such as planter retaining walls and cascading steps anchor the composition to the site. The original architect was William F. Cody, FAIA. A remodel and addition was completed by LEA Architects LLC. (LEA Architects LLC.)

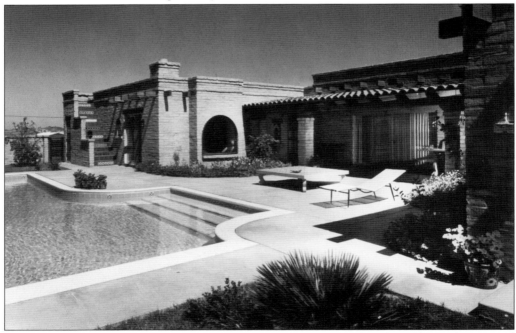

Heuser Hacienda, c. 1960s. This east coast client was familiar with Colonial homes but wanted to build an adobe residence. The large, one-story home focuses on an exterior courtyard with a swimming pool, an outdoor fireplace, and open stairs to a roof deck. George W. Christensen and Associates was the architect; this firm went on to design over 30 custom residences in Paradise Valley during the next 40 years. (Donald J. Christensen, W. Brent Armstrong.)

HEUSER HACIENDA, C. 1960S. The interior features an exposed, hexagonal tile floor, beehive fireplace, whitewashed walls, and an exposed wood roof structure. (Donald J. Christensen, W. Brent Armstrong.)

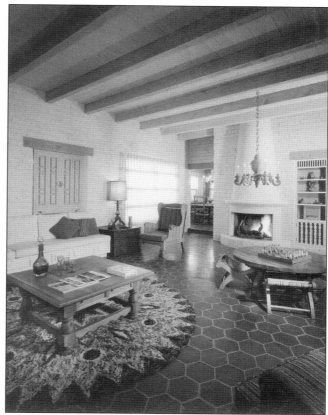

GONZALES RESIDENCE. This award-winning 1966 private custom desert residence is located at North Palo Christi Drive. The home character suggested an abstracted Pueblo approach to the forms. The architect desired a cluster of simple boxes arranged to encourage an open way of living. Exterior walls that are exposed to the interior are slump block units with a painted mortar wash. Interior floors are of burnt adobe and were given a dark brown stain to visually contrast with the walls. Bennie M. Gonzales, FAIA, was the architect. (Author's collection.)

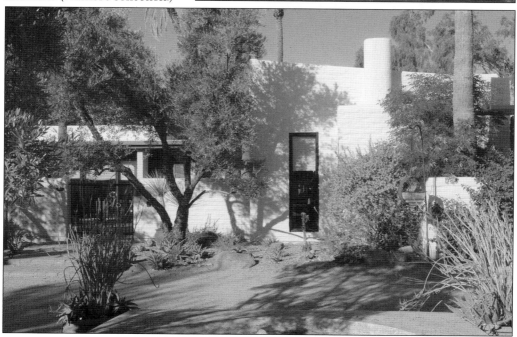

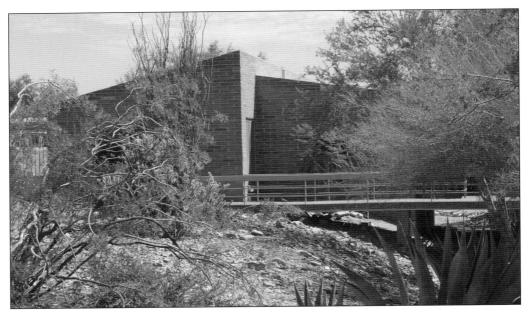

DR. FRANK S. TOLONE RESIDENCE. This 1967 award-winning residence is located on East Desert Jewel Drive. The home is sensitively sited with a few dry washes. A cluster of one-story components with varying pitched roofs are provided along with walls of exposed masonry. Grey-colored wood details are found at vertical sun shading panels and bridge railings. The architect was James T. Flynn, AIA. (Author's collection.)

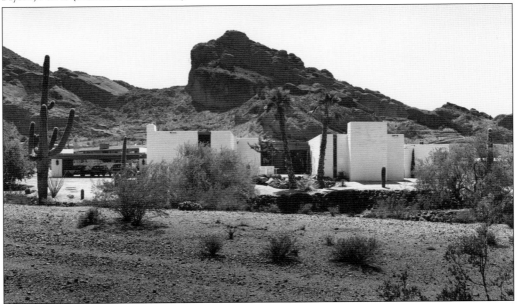

PETERSON RESIDENCE, 1968. The Dr. Rex and Del Peterson residence has four bedrooms and three bathrooms on North Fifty-second Street. "One of the purest concepts is a white house in the desert. Modular post and beam is combined with rustic pueblo massing to unite in what the architect calls the character Scandinavian Pueblo," according to the architect's brochure. George W. Christensen and Associates was the architect. (Neil Koppes, CCBG.)

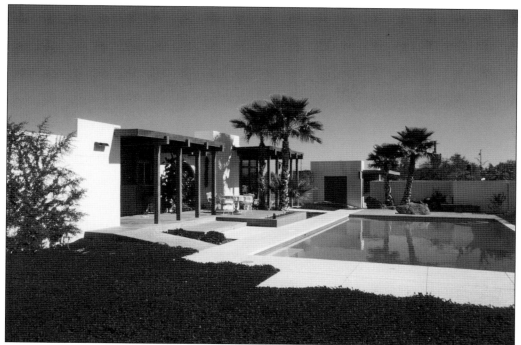

PETERSON RESIDENCE, 1968. The main residence overlooks the swimming pool and Camelback Mountain to the south. (Neil Koppes, CCBG.)

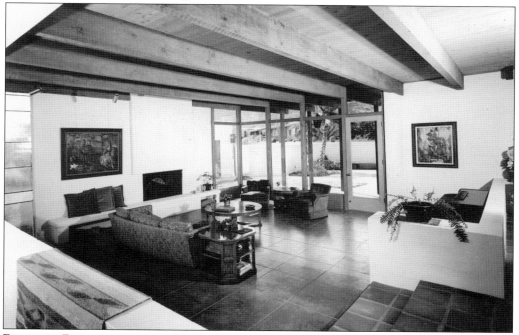

PETERSON RESIDENCE, 1968. This interior takes advantage of multiple levels with the entry overlooking the taller living space beyond. White walls, exposed rough-sawn roof framing above, and tiled floors are appropriate for the Sonoran Desert. (Neil Koppes, CCBG.)

COOK RESIDENCE, 1973. This 1969 residence was at 3627 Camino sin Nombre. The two-story home used passive solar concepts. A west-facing, thick sculpted masonry wall with varied small window openings was not unlike the iconic Le Corbusier's Ronchamp Chapel found in France. The architect was Jeffrey Cook, AIA. The home has been demolished. (Author's collection.)

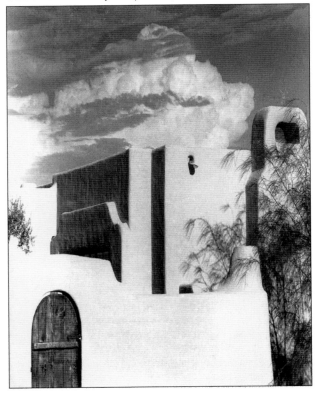

CASA CRISTINA, 1977. This residence on North Forty-sixth Street used hand-crafted, 16-inch thick adobe, hewn wood beams, gently rounded corners, and windows that do not necessarily match up with any other windows in the same facade. Artist William F. Tull, who designed the home, stated: "Abstract shadows and shapes in my paintings are also used in my architecture." He preferred "peace-quiet-everything soft and sculptured." The home was featured in the *Fire in the Sky* film and in fashion publications. (Bob Ross Photos, Joann Tull.)

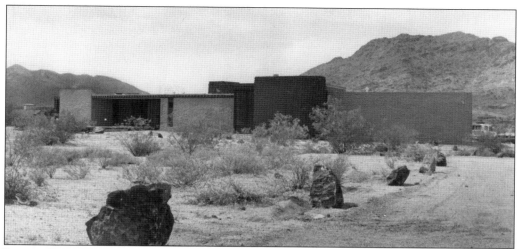

LARSON RESIDENCE. This 1974 residence was on East McDonald Drive and incorporated natural materials such as exposed masonry, natural stone, and full-height glazing. Massing provided a broken roofline with stepped forms. The plan integrates five patios and a four-car carport. The architect was John S.M. Hamilton. The home was demolished in 2012. (Mary Leonhard Photographer, AIA, Phoenix Metro.)

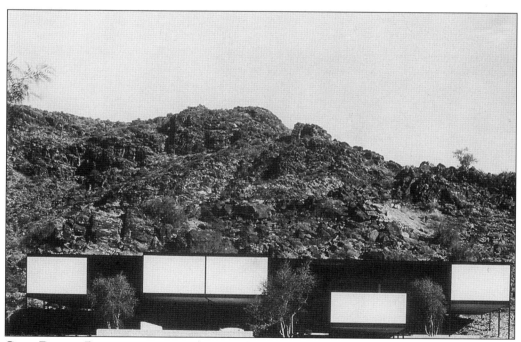

GARY DRIGGS RESIDENCE, 1970. This award-winning residence on North Shadow Mountain Road was elevated above the hillside to allow the natural landscape to be retained. The main structure is a steel column grid and features beams that are fully expressed throughout. Within the grid are taupe-colored plaster walls or full-height glazing. Alfred Newman Beadle was the architect. (Arizona State University Libraries.)

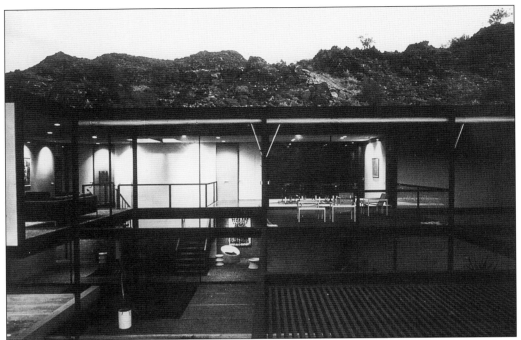

GARY DRIGGS RESIDENCE, 1970. The glazing is layered in the plan to provide a transparency from space to space and to frame desert views beyond. An accessory building accommodates a guest suite that is placed at grade and defines the main entry. (Arizona State University Libraries.)

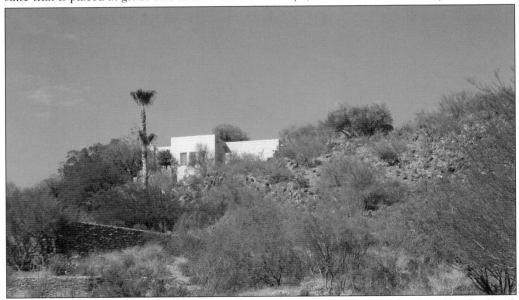

BOMBECK RESIDENCE, 1971. A residence for humorist and author Erma Bombeck and her husband, Bill, and their family is found on a raised hillside ridge with spectacular views. Ford Powell and Carson of San Antonio, Texas, was the architectural firm, and Chris Carson, FAIA, was the principal designer. The firm, founded in 1939 by architect O'Neill Ford, is well known for its regional design approach, influencing generations of Texas architects. (Author's collection.)

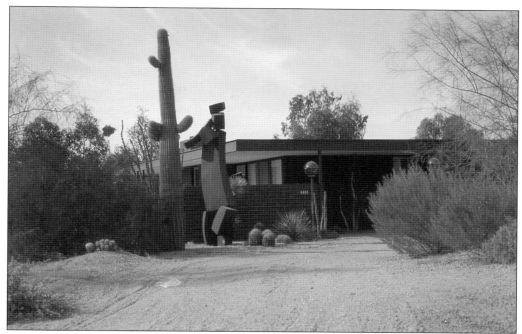

FLYNN RESIDENCE, 1973. This custom residence and adjacent work studio at North Fifty-First Place was designed and built by 1971. The exterior forms are defined by an exposed black steel frame with a dark brown brick and full-height glazing infill panels. The floor plan focuses on a southern courtyard and swimming pool with a dramatic Camelback Mountain view beyond. James T. Flynn, AIA, was the architect. (Author's collection.)

COOK RESIDENCE, 1973. This two-story residence is located on a hillside lot on North Hillside Drive. Visitors park at the upper level open carport and then descend down into the home. The walls are of exposed masonry with brushed mortar joints capped with a wood-framed and pitched clay tile roof. Southeastern-facing windows take advantage of Mummy Mountain and Camelback Mountain views. James T. Flynn, AIA, was the architect. (Author's collection.)

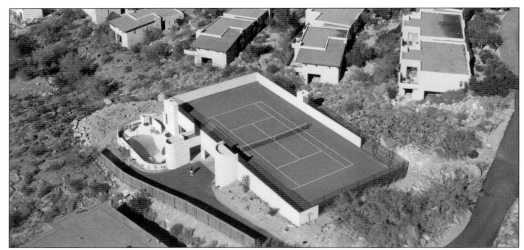

ROSEWALL RESIDENCE, 1974. The award-winning Ken Rosewall residence was built on a custom home lot at the John Gardiner's Tennis Ranch. The novel design approach for a professional tennis player placed a full-size tennis court on the roof and the main residence underneath at the lower north end. This design left more of the natural desert untouched. George Christensen, FAIA, was the architect. (Neil Koppes, CCBG.)

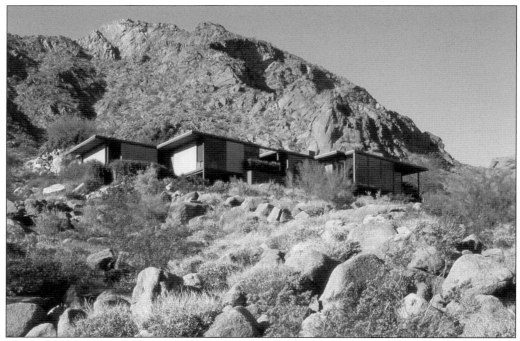

SHOENBERG RESIDENCE, 1975. This 3,200-square-foot residence was designed at John Gardiner's Tennis Ranch. The structure features exposed tubular steel with the roof drainage downspouts integrated within structural columns. Infill panels are of taupe-colored plaster or tinted glazing. Interiors have spectacular, elevated views of Paradise Valley and Scottsdale. Reginald G. Sydnor, AIA, was the architect; he also designed the Ambler, Gardiner, and Sydnor residences of Paradise Valley. (Neil Koppes.)

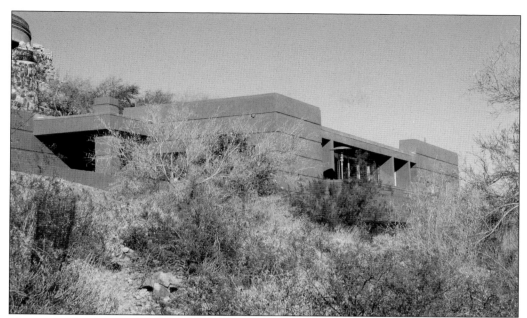

MAHONEY RESIDENCE. This 1977 residence located at North Cottontail Run is a horizontal composition hugging the hillside property. A linear window is shaded above by a continuous, wood-clad canopy and flanked by solid plaster walls to each side. The architect was Jones & Mah Architects Inc. (Author's collection.)

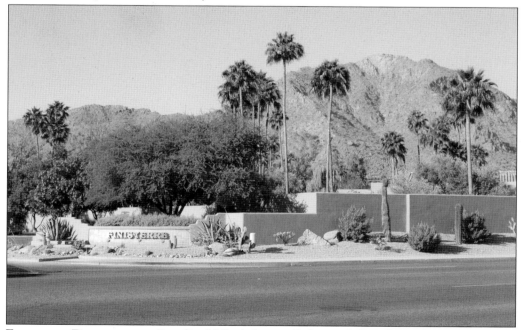

FINISTERRE DEVELOPMENT. Paradise Valley's first walled, guarded, and gated community was established in 1978 at the southwest corner of Invergordon Drive and Lincoln Drive. This was a planning precedent, as existing open desert spaces did not extend through the development. Nelson Kubicek Architects designed the wall. (Author's collection.)

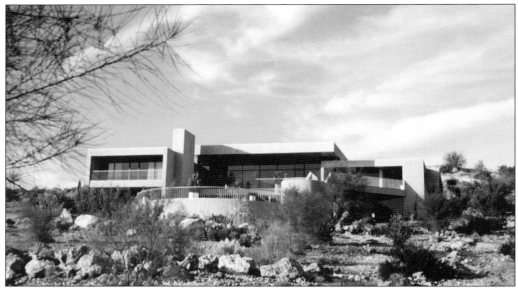

SMITH RESIDENCE, 1981. The two-story, 6,500-square-foot Arnold Smith residence is located on East Palo Verde Drive. Clean, crisp forms and concrete walls step down the hill and frame Phoenix views. A roof canopy floats over interior spaces that extend functionally and visually to exterior terraces and patios. The architect was Knoell & Quidort Architects. (Knoell & Quidort Architects.)

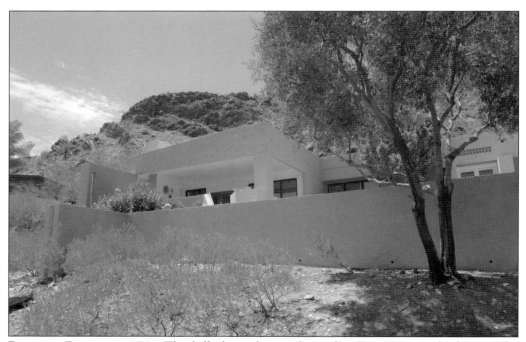

PETERSON RESIDENCE, 1981. This hillside residence is located on East Hummingbird Lane. The home is composed of plastered cubic volumes that sit into the hill, providing an outdoor living room with a fireplace and a swimming pool level. The architect was Jack Peterson & Associates. (Author's collection.)

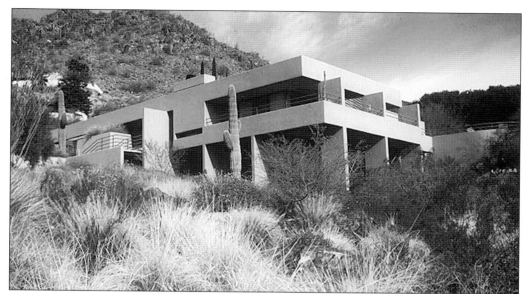

GOODMAN RESIDENCE, 1985. An existing Mid-century residence on a hillside property at North Red Ledge Drive received major additions and renovation to become a three-story, 5,000-square-foot residence. The built results are quite dramatic, with the sculpted forms of solid masonry walls interlocked with carved voids and window openings. The masses sit well on the pitched desert property. The architect was Edward B. Sawyer Jr. (Edward B. Sawyer Jr.)

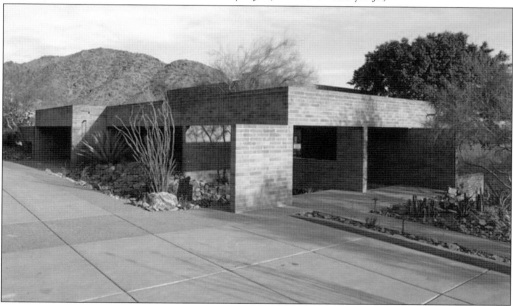

LEIN RESIDENCE, 1984. This East Hummingbird Lane residence includes two stories, a 2,750-square-foot main residence, and guest quarters of 928 square-feet. The architecture exploits the use of exposed multi-fired masonry walls at the exterior and interior. The forms interlock and overlap in various sculptural configurations to frame distant views, block unwanted sun, define privacy, and expand the interior space to surrounding outdoor patios. The architect was Edward B. Sawyer Jr. (Edward B. Sawyer Jr.)

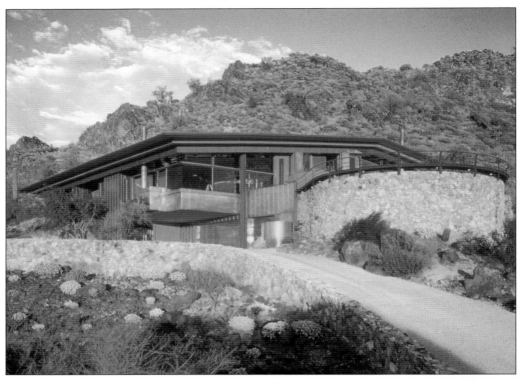

WEISS RESIDENCE, 1988. This two-story residence is located east of the Paradise Valley Country Club golf course on a one-acre rocky hillside property. The mountainside residence "has been designed to minimize its physical impact on the natural environment, which surrounds it, while maximizing the enjoyment of the site's spectacular city and mountain views," stated architect William P. Bruder, FAIA. (Will Bruder + Partners Ltd.)

WEISS RESIDENCE, 1988. The exterior material palette is naturally aged copper, native rock quarried from the site during excavation, and weathered steel. The interior materials are resawn spruce ceilings, flagstone flooring, wool carpeting, copper, and white oak for paneling, doors, and cabinets. (Will Bruder + Partners Ltd.)

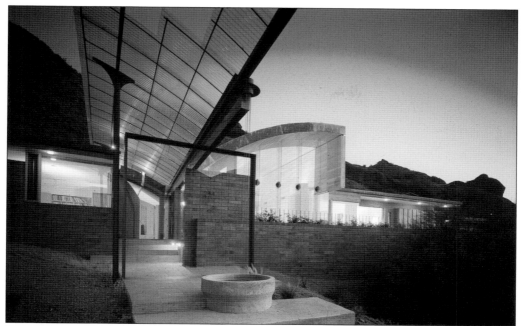

HALAS RESIDENCE, 1985. This one-story 2,500-square-foot residence is located at East McDonald Drive. The owner was a well-known psychologist specializing in women's issues and marital counseling. She had a professional office, but the house needed to accommodate home appointments without compromising privacy. The plan has a rounded form that directs runoff away from the structure, and a curved roof form meant to sympathize with Camelback Mountain's ancient, rounded profile. The architect was Jones Studio Inc. (Jones Studio Inc.)

ZUBER RESIDENCE. This 1989 hillside home on East Indian Bend has a floor plan that overlaps an upper split-face block component for private uses with a lower stucco component for more public uses. The master bedroom was perched above as the inner sanctum and control tower, while framing views of the upper pool, gallery, and Camelback Mountain. A skeletal bridge extends from the living room and functions as a gateway below as visitors approach the house. The architect was Antoine Predock Architects. (Author's collection.)

CUMMINGS RESIDENCE, 1989. This East Nauni Valley Road residence was designed for a two-acre property and a 7,500-square-feet program. Site planning was based upon a four-foot grid and proposed an east-west plan with outreaching wings. The plan incorporated a series of three different courtyards of various scales and purposes. The architect was Sydnor Architects, PC. (Mark Boisclair Photography Inc.)

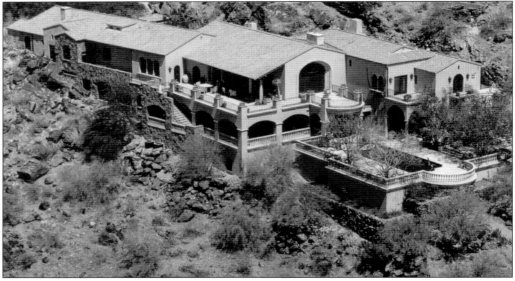

DORRANCE RESIDENCE, C. 1992. This hillside property overlooks the Paradise Valley Country Club golf course. The original architect states that the home is "nestled into a larger rock outcropping, the mountain unites with its knoll. The lower level is very intimate with window wells and the deck level is reminiscent of a ship. The upper level is connected by four stairways, which add a sense of flow between levels. A long art gallery functions as the upper circulation." The architect was George Christensen, FAIA. (Donald J. Christensen, W. Brent Armstrong.)

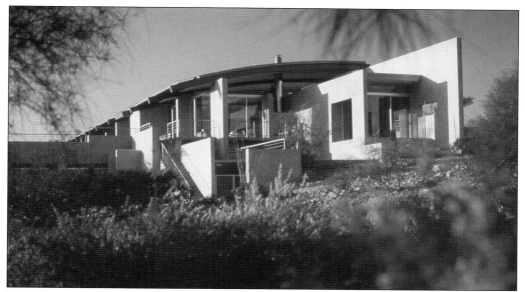

DEBARTOLO RESIDENCE, 1993. This two-story home at North Thirty-third Street is 5,600 square feet. The plan provides a major wall to the severe western exposure while the remaining open sides frame distant city and mountain views. Jack DeBartolo Jr., FAIA, was the owner and architect. (Jack DeBartolo Jr., FAIA.)

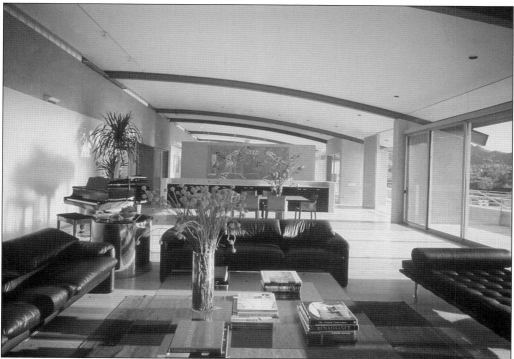

DEBARTOLO RESIDENCE, 1993. The design strategy takes advantage of daylight throughout the interior and proposes a floating pavilion roof structure. The floor plan is primarily an open loft where interior partitions were minimized. (Jack DeBartolo Jr., FAIA.)

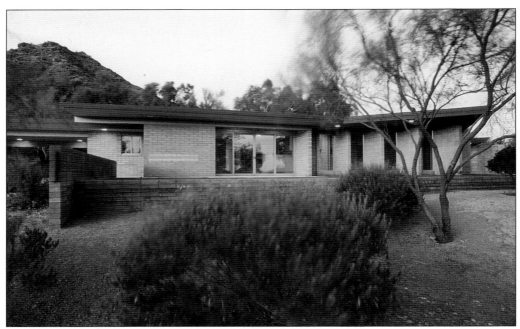

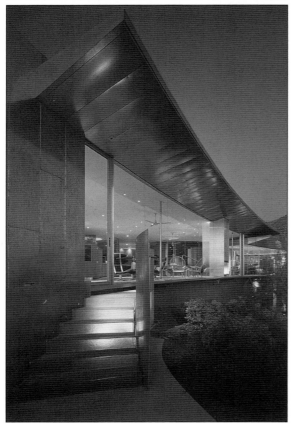

KORNEGAY RESIDENCE, 1993. The original 1,800-square-foot structure dates from 1955 and was designed by Edward Loomis Bowes. A major renovation and 3,400-square-foot additions to this hillside house integrated it with the site. With adjacent homes arriving over the years, a new plan provided privacy and controlled views. Exposed concrete block, plastered ceilings, scored concrete floors, wood cabinetry, and steel windows were provided. The architect was John Douglas, FAIA. (John Douglas Architects.)

TOWNSEND RESIDENCE, 1997. This art collector's residence is located on one acre at East Hummingbird Lane and was a major addition and renovation of an existing structure. The two-story, 4,800-square-foot house is an eyebrow floating over the natural topography, while focusing on the northeasterly view of the McDowell Mountains. The house responds to the owner's desire for a place of quiet reflection. The architect was Will Bruder Architect Ltd. (Will Bruder Architect Ltd.)

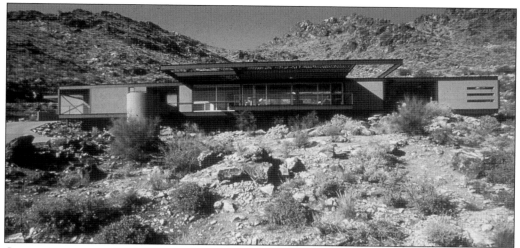

GRUBER RESIDENCE, 1998. This residence is on a one-acre hillside property at North 58th Place. The 4,000-square-foot floor plan is stretched in an east-west direction with a solid western wall and enclosed garage to the east. The midsection of the floor plan opens to a southern swimming pool while the north provides full-height glazing to frame the valley views below. The structure is exposed tubular steel with plastered wall panels, full-height glazing at more public spaces, and smaller window openings at the private zones. Rich Fairbourne, RA, of The Construction Zone completed the construction after the architect's passing. The architect was Alfred Newman Beadle. (Dan Gruber.)

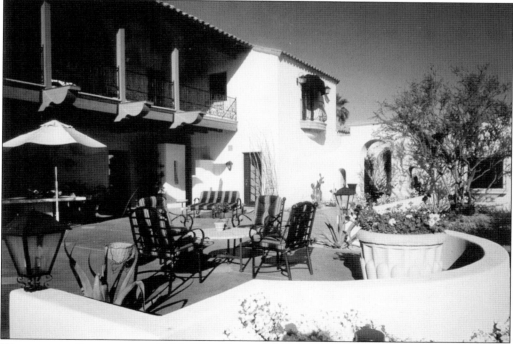

WITHYCOMBE RESIDENCE, C. 1996. "The Shangrila Resort gave way to four acres of land, which became a family resort. All bedrooms are located on the balconied second level providing maximum views of Camelback Mountain," according to the architect George W. Christensen, FAIA. (Donald J. Christensen, W. Brent Armstrong.)

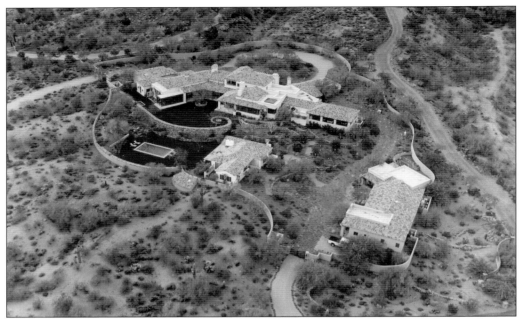

DORRANCE RESIDENCE, 1999. This aerial view is of the sprawling residence on North Cameldale Way. The residence's scale is broken up with one and two-story components, a shifting plan, shaded overhangs, and various-size window openings. The architects were George W. Christensen, FAIA, and Erik Peterson. (Dino Tonn Photography.)

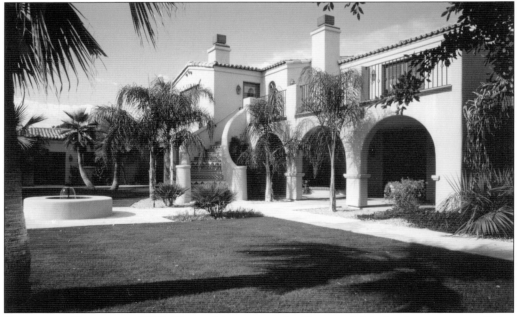

SCHUCHTER RESIDENCE, 1999. The architect notes the "long and thin in plan, two-story living room in the middle allows the bedrooms to be on one side and family living on the other. Rather than expensive details, simplicity and proportions were used as the main elements." The architect was George W. Christensen, FAIA. (Donald J. Christensen, W. Brent Armstrong.)

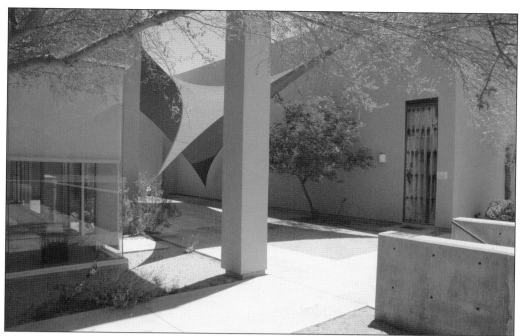

UDINOTTI STUDIO. Adjacent to a c. 1928–1930 Robert Evans adobe residence on East McDonald Drive, this 2,500-square-foot, two-story daylit artist's studio, art display, and guest quarters was built in 1999. The owner describes the character as a Contemporary Adobe, in which the walls are abstracted planes, glazing faces a defined patio, and a tall weathered wood door allows large canvases to enter the studio along with people. The architect was John Douglas Architects. (Author's collection.)

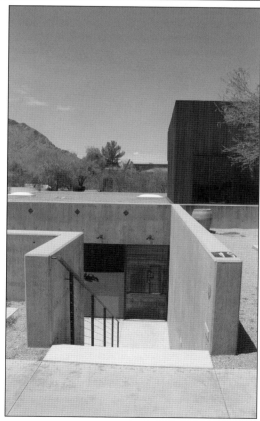

UDINOTTI MUSEUM OF FIGURATIVE ART. A later phase in 2006 included a 1,900-square-foot subterranean gallery of cast-in-place concrete walls, exposed steel trusses, and metal decking. It was "placed underground as not to interfere with the view of Camelback Mountain—a sacred mountain" from the adjacent studio, according to Agnese Udinotti. The gallery is entered from a sunken sculpture courtyard. A rusted, steel-clad upper-level gift shop with a roof deck for views is located above. The architect was The Construction Zone. (Author's collection.)

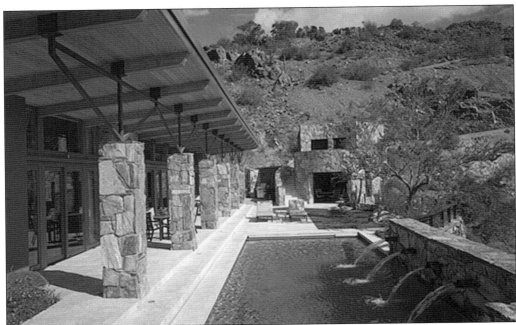

MORGAN RESIDENCE, 2001. This hillside room on East Moonlight Way restored a previously damaged site. An existing retaining wall was preserved and extended to anchor the guesthouse and a new driveway. The main house is disciplined with a clear structural logic, while the guesthouse is free and curvilinear. The composition creates a variety of outdoor experiences and captures dramatic views. The architect was Knoell & Quidort Architects. (James L. Christy of Jim Christy Studio.)

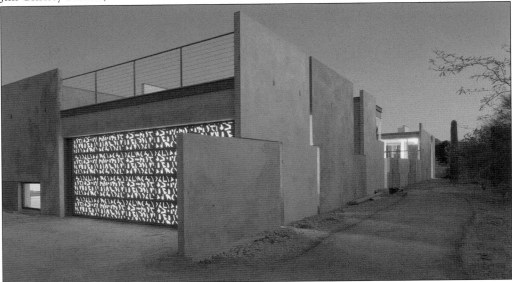

PLANAR RESIDENCE, 2002. This 3,200-square-foot home provides for a large contemporary art collection that includes pieces by Bruce Naiman, Robert Ryman, Jeff Koons, and Jannis Kounellis. The structure is composed of concrete tilt-up panels that define an exterior courtyard. The architect was New York–based Steven Holl Architects. (Bill Timmerman.)

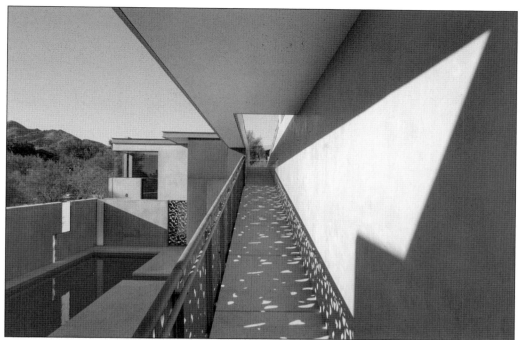

PLANAR RESIDENCE, 2002. An exterior ramp positioned within a courtyard provides access through the roof structure to a view deck. (Bill Timmerman.)

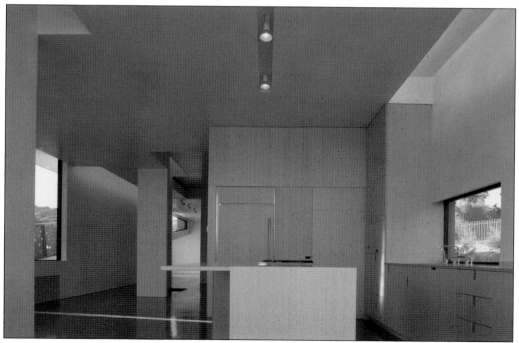

PLANAR RESIDENCE, 2002. This interior view shows the open plan with introduction of daylight from various sources, minimizing the interior glare from a single source. (Bill Timmerman.)

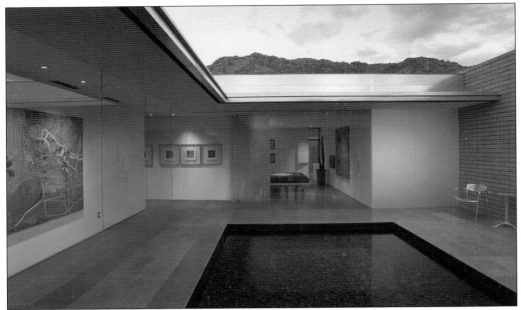

DEBARTOLO RESIDENCE, 2005. Miramonte House 69 is on East Lincoln Drive and is a 3,000-square-foot custom home. The plan exploits the traditional notion of a courtyard in the desert and opens it to the sky above. The structure is exposed masonry with full-height glazing and natural stone floors. The architect and owner is Jack DeBartolo Jr., FAIA. (Jack DeBartolo Jr., FAIA.)

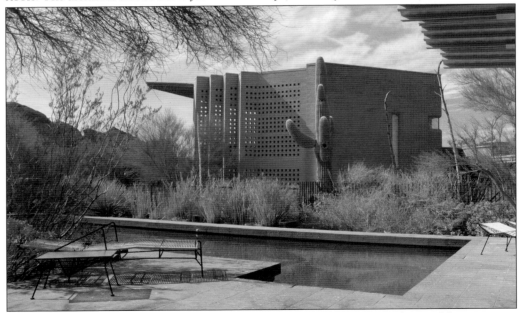

FERRIS RESIDENCE, 2006. This 5,000-square-foot, two-story residence was designed for a one-acre property on Camelback Manor Drive. The project started as a guest cottage in the 1940s and led to a series of renovations and additions from 1987 to 2006. The home was designed to be virtually invisible in its natural setting as the exterior colors mimic the shadows seen in the dense undergrowth. The architect was John Douglas Architects. (John Douglas Architects.)

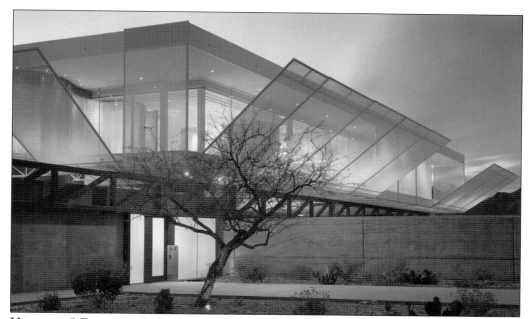

HOUSE OF 5 DREAMS, 2004. This three-story, 30,000-square-foot residence is located on East Stanford Drive on approximately three acres. The private penthouse residence hovers 14 feet above grade. A glass roof and floor inserts scatter circular light around their undulating translucent "flower" space. Roof and floor planes frame panoramic views of the city skyline and desert mountains. The architect was Jones Studio Inc. (Jones Studio Inc.)

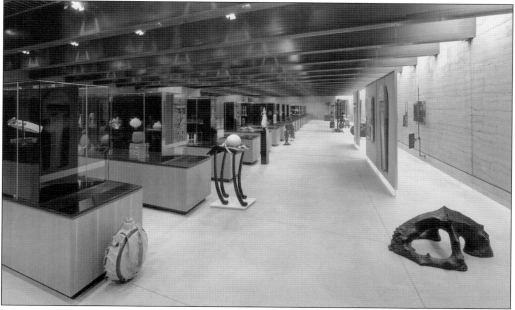

HOUSE OF 5 DREAMS, 2004. This interior view is of a private museum for the display, storage, and protection of Pre-Columbian art. The below-grade space is defined by four-foot-thick, rammed earth walls at the perimeter and an exposed, clear-spanning steel roof structure above. (Jones Studio Inc.)

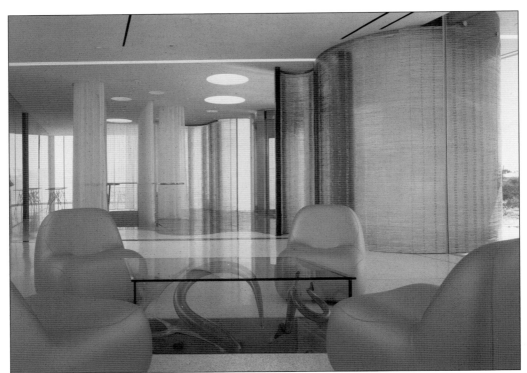

HOUSE OF 5 DREAMS, 2004. The interior conveys an extremely sophisticated, elegant, and minimalistic ambiance. Transparency and translucency is explored throughout. (Jones Studio Inc.)

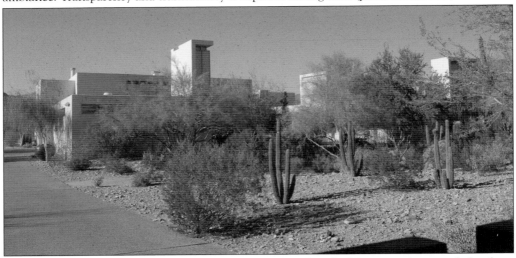

WILLIAMS RESIDENCE, 2007. This 6,206-square-foot East Stanford Drive residence includes three bedrooms and six bathrooms. This two-story approach places the main living, dining, kitchen, and outdoor dining at the upper level as a "reversed living room" and the private spaces, such as bedrooms, on the first level. The home was conceived as a "thick-mass casting" and has white cast 20-inch-thick concrete walls. The two-story volumes define an entry courtyard. Colors include subtle grays, silvers, and green casts of the desert landscape. The architect was Marwan Al-Sayed Architects Ltd. (Author's collection.)

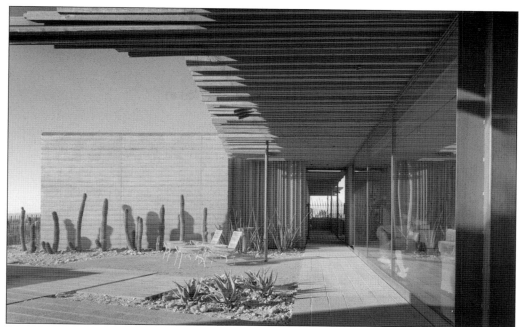

LACEY RESIDENCE, 2012. A three-building cluster, with a main house, garage, and guesthouse, is found on East Stella Lane. The client desired a retreat and a home and it was his implied program for a residence to represent progressive contemporary thinking ground in the fundamentals of "mind and shadow." A courtyard was formed in this hacienda diagram. Rammed earthen walls were used given their resistance to climatic forces, insulating superiority, structural capability, and inherent natural beauty. Wood was used intentionally, with weathering in mind. The architect was Jones Studio Inc. (Jones Studio Inc.)

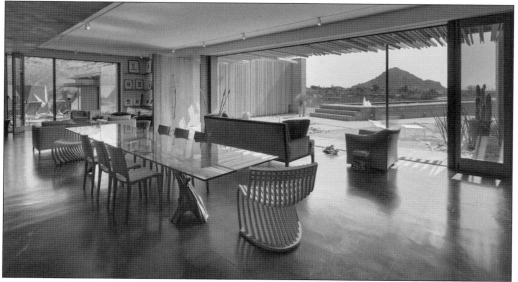

LACEY RESIDENCE, 2012. The interior is psychologically expanded and connects with the outdoors with an open plan, full height glazing, desert landscaping close by, and a framed Camelback Mountain view. (Jones Studio Inc.)

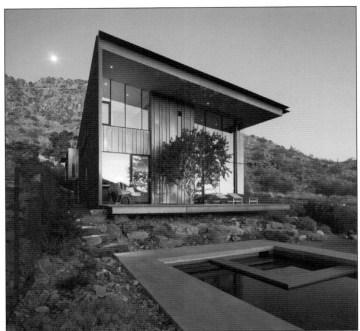

JARSON RESIDENCE, 2009. This two-story residence is located on North Charles Drive. The home is for two real estate professionals and their two sons. A mysterious, refined dark object in its rugged natural landscape, the house provides a place of quiet reflection. The entry, office, and bedrooms are on the upper level with living and dining rooms; a media music chamber and potter's studio are tucked beneath. The architect was Will Bruder + Partners Ltd. (Will Bruder + Partners Ltd.)

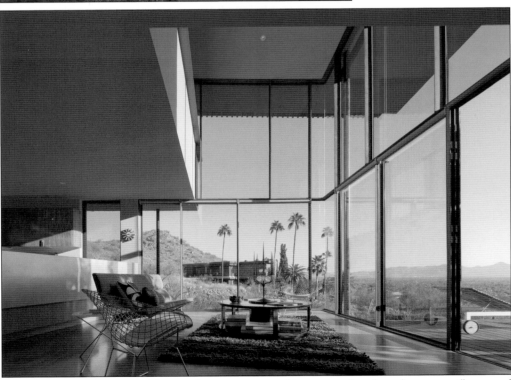

JARSON RESIDENCE, 2009. This residence interior utilizes natural cork and concrete floors and wall planes of translucent glass. Cabinets of cherry and stainless steel articulate the interiors. (Will Bruder + Partners Ltd.)

BIBLIOGRAPHY

Barry Goldwater Memorial. Town of Paradise Valley, February 14, 2004.

Beadle, Alfred Newman. Bernard Michael Boyle, ed. and Diane M. Upchurch, associated ed. *Constructions: Buildings in Arizona.* Historic Publications No. 3, Tempe, AZ: School of Architecture, Arizona State University, 1993.

Carlson, Fran. "Spell It MacDonald Please." *Scottsdale Scene.* March 1984: 85–86.

Driggs, Gary. *Camelback: Sacred Mountain of Phoenix.* Tempe, AZ: Arizona Historical Foundation, Arizona State University, 1998.

Fudala, Joan. Images of America: *Scottsdale.* Charleston, SC: Arcadia Publishing, 2007.

A Guide to the Architecture of Metro Phoenix. Central Arizona Chapter, American Institute of Architects. Phoenix, AZ: 1983.

Marill, Michele C. *Phoenix Country Day School: Voices in the Desert.* Bookhouse Group Inc.

Preserving the Desert Lifestyle: The 25th Anniversary of the Town of Paradise Valley. Scottsdale, AZ: The Parish Agency, 1987

Miles, Candice St. Jacques. "Pandemonium Found: Architects Comment on Paradise Valley's Lost Style." *Arizona Living.* Volume 14, Number 5. May 1983: 16–23.

O'Meara, Rosie. "Figuring The Angles." *The Arizona Republic Sun Living.* Section 5. June 15, 1958.

"Ranches, Lodges, Inns, Hotels, Resorts in New Accommodations Guide." *Scottsdale and Paradise Valley News.* Scottsdale Chamber of Commerce, Volume 1, Number 2. 1956–1957.

Stevenson, Charles S. *We Met at Camelback! The Story of Jack and Louise Stewart at Their Camelback Inn.* Arizona Desert Publishing Company, 1968.

Town of Paradise Valley 40th Anniversary. Historical Advisory Committee. Photography: Kathryn Gasser. Payout: Kathryn P. Yoder. Town of Paradise Valley, 2011.

DISCOVER THOUSANDS OF LOCAL HISTORY BOOKS FEATURING MILLIONS OF VINTAGE IMAGES

Arcadia Publishing, the leading local history publisher in the United States, is committed to making history accessible and meaningful through publishing books that celebrate and preserve the heritage of America's people and places.

Find more books like this at
www.arcadiapublishing.com

Search for your hometown history, your old stomping grounds, and even your favorite sports team.